Wild Flowers

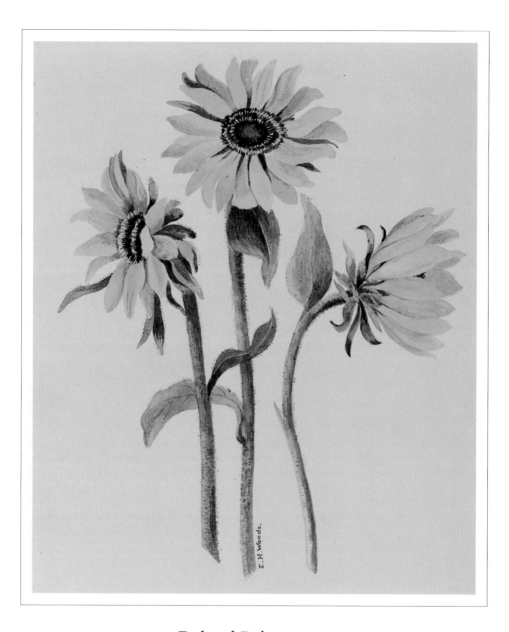

Deltoid Balsamroot
Balsamorhiza deltoidea

Wild Flowers

Emily Carr

Illustrations by
Emily Henrietta Woods

ROYAL **BC** MUSEUM

Published by the Royal BC Museum,
675 Belleville Street, Victoria, British Columbia, V8W 9W2, Canada.

Edited by Kathryn Bridge and Gerry Truscott, RBCM.
Designed by Chris Tyrrell, RBCM.
Set in High Tower Text.
Digital imaging by Carlo Mocellin and Kim Martin, RBCM.
Botanical information provided by Kendrick Marr, RBCM.
Printed in Canada by Friesens.

Front and back covers: Bunchberry *Cornus canadensis*.

Library and Archives Canada Cataloguing in Publication Data
Carr, Emily, 1871–1945.
 Wild Flowers

 Text by Emily Carr; illustrations by Emily Henrietta Woods,
who was Carr's childhood drawing teacher. Cf, Foreword.
 The originals of Carr's manuscript and Woods' botanical illustrations
reside in the collections of the BC Archives; neither have been published
before now. Cf. Foreword and Afterword.
 ISBN 0-7726-5453-0

 1. Wild flowers – British Columbia. 2. Wild flowers – British
Columbia – Pictorial works. 3. Botanical illustration – British
Columbia. I. Woods, Emily Henrietta. II. Bridge, Kathryn Anne, 1955-
III. Royal BC Museum. IV. Title.

QK203.B7C37 2005 582.13'09711 C2005-960236-8

Contents

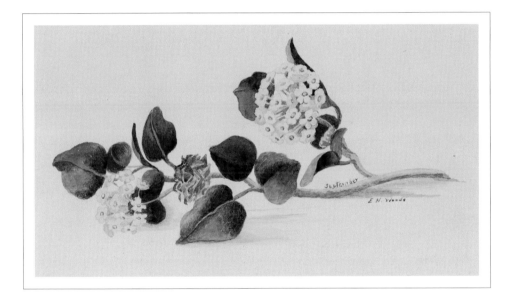

Yellow Sand-verbena
Abronia latifolia

BUTTERCUPS and DAISEYS

Buttercup let the secret out long befor the birds sung and the frogs croaked it. Long, long before the Sun gave your nose its new crop of freckles and burst the buds of garden flowers. In dots of yellow Buttercup wrote all over the hillside 'Spring has come!' Hard green pills that had been buttercups buds yesterday were no bigger than a drop of rain, were today golden cups full of sunshine.

Miss Daisey was not going to be out done by old Buttercup. She threw back her green hood stroked out the white peticote over her pink undies and flopped to the ground on her back staring at the sky, or at any one who got between her and the sky, from an eye just as golden as Buttercup himself. The lawns under the trees in the Park looked as if a very spotty whitewasher had attempted to do earth's ceiling.

Daiseys and buttercups although both were carpet flowers were not used in our rock playhouse because they were over before it was warm enough to play ladies out of doors. That ridge of rock that ran across our back feild was the favourite of all play-houses. Sky for roof, Spyrea and Syringa walls, but the carpets! What colors, what richness of pile. The drawingroom had pink shepherds purse (real enough to walk on but you did not, much) you sat on stones for chairs fearful of treading on the bees, and butterflies liked to dance on the shepherd's purse carpets too. The diningroom carpet was of blue for-get-me-nots. The kitchen plain green moss, very soft and thick because (as we liked to tell a pretend Mrs Smith.) "It sops up the grease (pretend) of our cookery (pretend) and is so much safer for falling china." As there was a gully between Kitchen and diningroom which must be leapt, a good deal of dolls china did fall.

This page from Carr's manuscript shows how she edited and refined an early draft.

A Small Treasure

Foreword by Kathryn Bridge

*E*mily Carr composed the 21 vignettes that make up "Wild Flowers" during the autumn and winter of 1940–41, when she was mostly housebound, recuperating from a stroke suffered the previous June. She had also endured an angina attack in 1937 and a more serious heart attack in 1939. While spending many weeks in hospital recovering from these earlier ailments, she turned to writing, and wrote most of what would later be her first book, *Klee Wyck*, drafts for her autobiography, and other stories.

After the stroke, at the age of 69, Carr was not as mobile as she wanted, confined indoors, and ordered by her doctor to stay in bed for one day each week. If she could not be outside, then the next best thing was to recreate the feelings of being outside, among the wild flowers. Capturing their essence in words challenged Carr. It was a good tonic and important therapy.

In February 1941, she wrote to a friend, saying that the weather made her feel optimistic. "Today has been wonderful, winter and spring shaking hands." To another friend she announced, "I have just finished a fair sized manuscript no one has seen it yet."

"Wild Flowers" has never been published – until now. For 65 years it has existed as a typescript with hand-written corrections and additions. It was clearly unfinished and revealed Carr's writing at a stage that was still unpolished. While the vignettes are uneven in quality, many read easily, her misleadingly simple observations ringing true with uncompromising clarity. But the manuscript was a work in progress, and a little rough around the edges, so we had to make some decisions about its presentation.

Carr was not the best typist, and so typos that were clearly slips of the fingers on the keyboard had to be corrected. But beyond this, the text itself has been edited in only three ways. First, obvious punctuation errors have been corrected in sentences that were difficult to read; for example, periods have been placed at the end of sentences that clearly end (but have no period typed) because the next sentence begins with a capital letter. Second, Carr's classic and consistent switching of the "*i* before *e*" rule resulted in words continuously spelled incorrectly; these have been corrected, to reduce reader irritation, thus "theif" is corrected to "thief" and "feild" to "field". Third, the occasional overwrites or additional words in ink (neither in Carr's

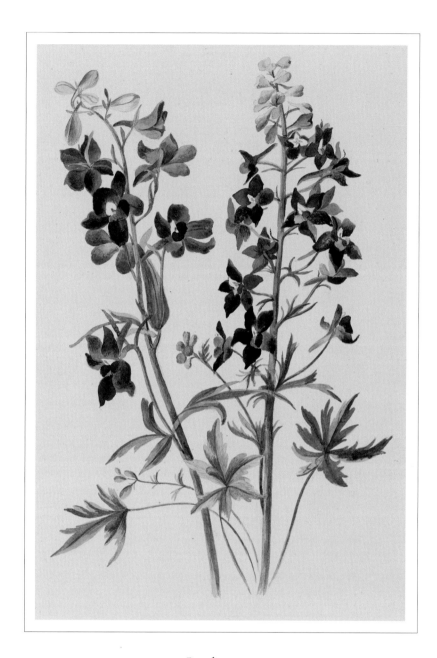

Larkspur
Delphinium sp.

nor her own editors' hands) have been ignored and Carr's original wording retained.

The original text shines through as Carr wrote it. She loved adding an extra *e* or *l*, as in "bulkey" (bulky) and "lilley" (lily), and often spelled words with *sh* when not required, such as "reashuring" (reassuring). She used lots of em-dashes, capital letters and underlines for emphasis. And her deliberately fanciful and often phonetic spellings are intact (for instance, "blossoms, attatched").

Emily Carr's *Wild Flowers* has been paired with botanical illustrations created by another Emily. Emily Henrietta Woods (1852–1916) was born in Ireland and arrived in Victoria in 1865 at the age of 13. She lived with her family at Garbally, their house beside Victoria Arm. She was a talented artist, employed as the drawing teacher at the Anglican girls school, Angela College, and also at Mrs Cridge's School for Girls. In a fitting coincidence, Emily Woods also taught art to Emily Carr, and Carr refers to her in *The Book of Small*. Emily Woods was deft in her pencil and watercolour landscapes, but her life's-work and focus for some 30 years was in the creation of more than 200 life-size watercolour illustrations of wild flowers, each identified with the scientific and common names of her time. We have paired Carr's words with Woods' drawings where possible; if the relationship between text and painting is not clear, the notes on pages 93-95 offer further explanation. Woods' fine detail provides realistic visuals to complement Carr's impressionistic descriptions.

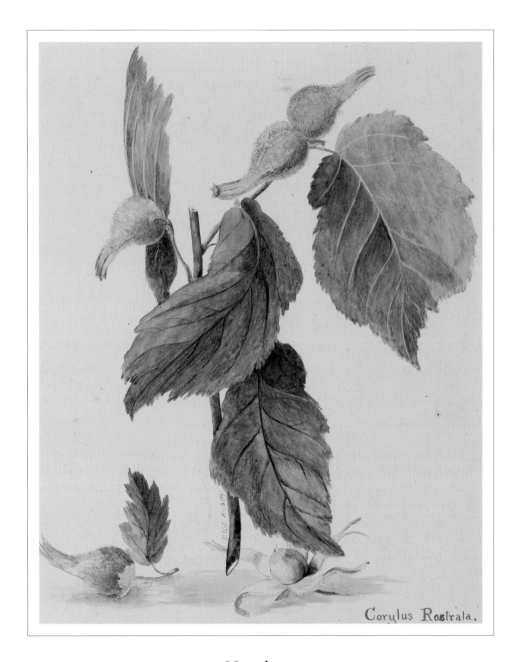

Corylus Rostrala.

Hazelnut

Corylus cornuta

Wild Flowers

Man and science have so magnified and
bewitched flowers many of them do not know
who their ancestors were nor which was their
native country, they have changed size, colour,
shape, they have had some things added and
some things stolen, they have been re-named,
re-constructed, naturalized into places where
they are native. It is enough to make any
flower tear her petals!

Smart though man be he cannot ever make a
brand new flower he has got to have a starting
point: a God-created wild flower.

Every exalted garden aristocrat has
its beginning in a wild flower and if that garden
flower is left to its own devices it will sneak
back to wildness.

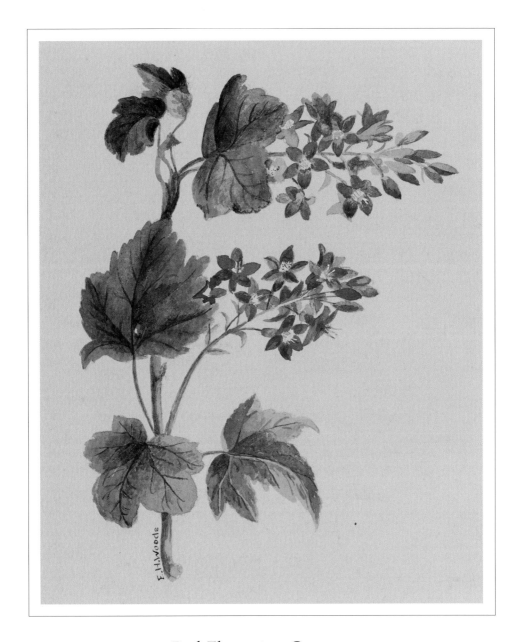

Red Flowering Currant
Ribes sanguineum

Ribes

Too tall, too hardwooded to be classed a plant, too short and stockey to be called a tree. The flowering shrub with qualities of both is sort of a go-between.

Ribes wake while the rest of the trees and flowers are still dead asleep. While winds are still bitter and frosts still nip. This "Flowering Currant shrub" as many people call her, this bare little bush begins to erupt little bumps all along her wood branches at the first burst of spring every glint of cool sunshine swells the bumps a little more till presently they burst and out squeezes a folded up rosy little tuft of blossom with a sweet, tart smell, very invigorating. This perfume wakes old bumble-bee. He has scarcely tuned up his buzz before "Ribes" is coral from root to top and her pungent scent is banging your nose with spring. There is just one other flowering bush that is a step ahead of Ribes. I do not know her name our childhood name for her was not pretty she is a self-assertive bouncer. With a loud smell she need not push herself forward nobody could miss her. Her new green is so vivid amongst the winter browns, her flower is rather insignificant she is a-twitter with bird life. The acrid tang of her smell fills the woods with spring. In the birds she rouses nesting ideas, leaving the bare trees they rush to the seclusion of her new bright foliage bringing nesting material with them. The sweetness and charm of Ribes makes her welcome in any garden. Not so this other shrub. Gardeners scorn her, root her out of cultivated places. Yet she is the first to bring in spring. Those who love rambling over wild land rejoice in this outlaw's hurry to have done with winter.

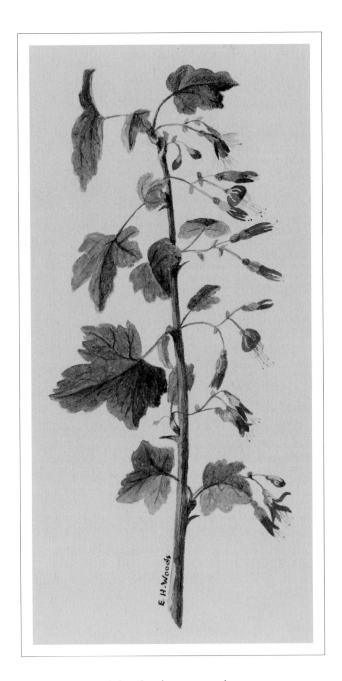

Wild Black Gooseberry
Ribes divaricatum

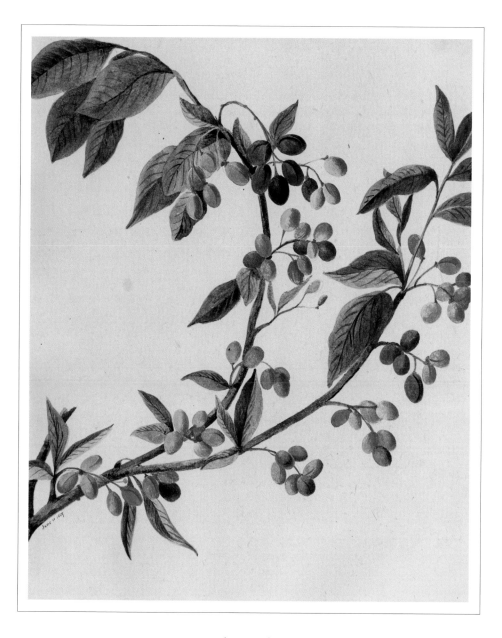

Indian-plum
Oemleria cerasiformis

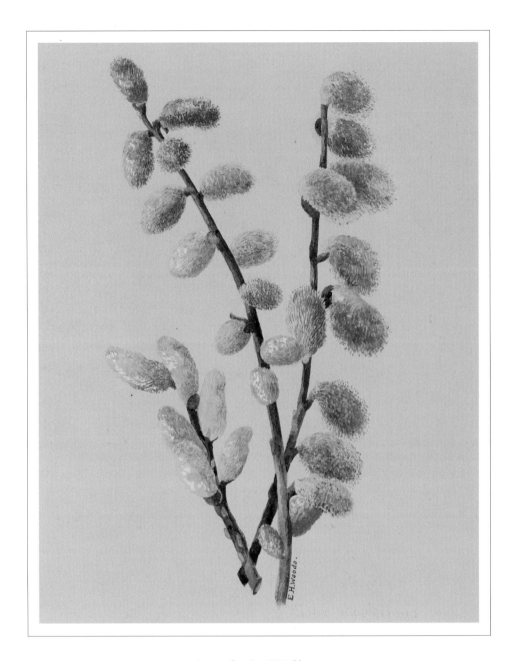

Scouler's Willow
Salix scouleriana

Catkin

Poor old Willow how they sentimentalize, how they exploit you through your catkins. Even standing ankle deep in water as you do in spring, human hands reach to grab the army of furry coated little catkins that you send out while it is yet cold to drive away the end of Winter. Your wrenched and broken boughs people take home and stick in jugs where they collect household dust. Perhaps the catkins will sit there till you make more next spring. They cannot go on with flowering, they cannot die, they are paralyzed. People prattle about "swamp kitties" and paste one fat catkin for a body and one smaller on top of it for a head, onto cardboard pencil a tail and whiskers to the thing and call it a cat. Please notice these pigmy monstrosity, catkin cats always have their backs turned as if they intimated, "Pshaw! can't we be honest catkins? Why must we be mock cats?"

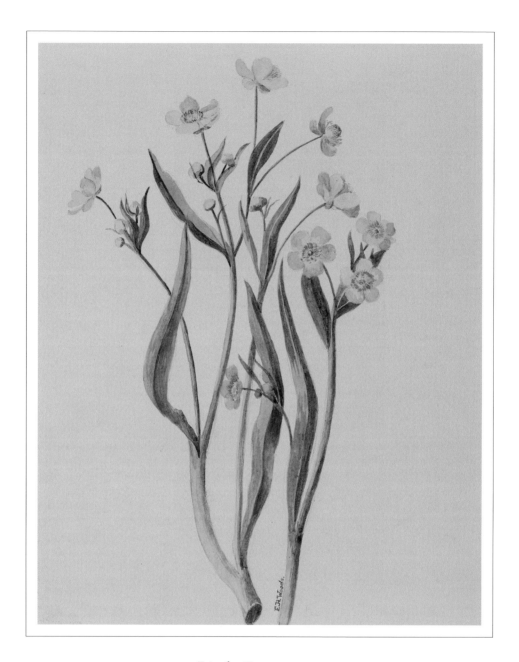

Little Buttercup
Ranunculus uncinatus

Buttercups and Daisies

Buttercup let Spring's secret out long before birds sang and frogs croaked it. Long, long before the sun gave your nose its new freckles and burst the buds of the garden flowers, dots of buttercup yellow wrote all over the side of Beacon Hill, "Spring is here!" Hard green pills that had been buds yesterday, were suddenly golden cups full of sunshine.

Miss Daisy was not going to be beaten by any old Buttercup, so she threw back her green hood, stroked her white dress over her pink undies, flopped flat and lay staring at the sky, or at anything that got between her and the sky. Her eye was just as golden as buttercup himself. The lawns in Beacon Hill Park looked as if a very spotty white-washer had been doing earth's ceiling.

Daisies and buttercups were carpet flowers, but we could not use them in our play-house on the rocky ridge in our back field, because, by the time it was warm enough for us to play "ladies" out of doors they were gone, but we did have lovely carpets on our play-floors – pink shepherd's-purse in the drawingroom, too lovely to walk on – besides it was crowded with bees. And the butterflies liked to dance there, so we sat on stones and watched. The dining-room carpet was blue forget-me-nots. The kitchen floor was one great rock with a carpet of thick green moss all over. We used to say, "It sops the grease up, my dear, and is much safer for the china." There was a gully between the dining-room and the kitchen which you had to jump so a good deal of doll crockery did fall.

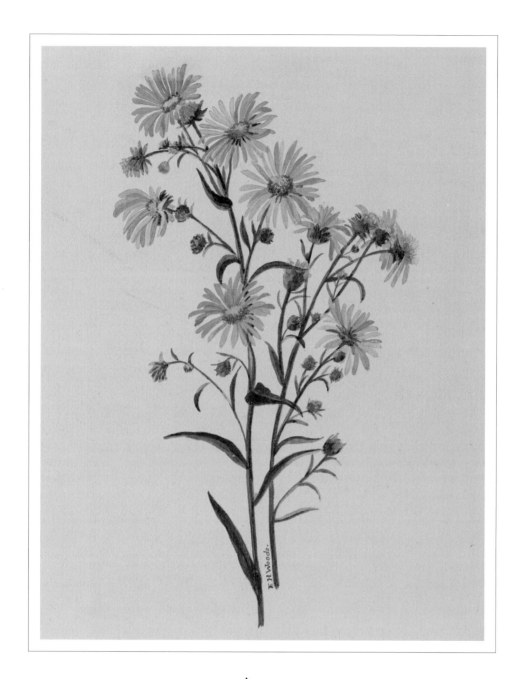

Aster

Aster sp.

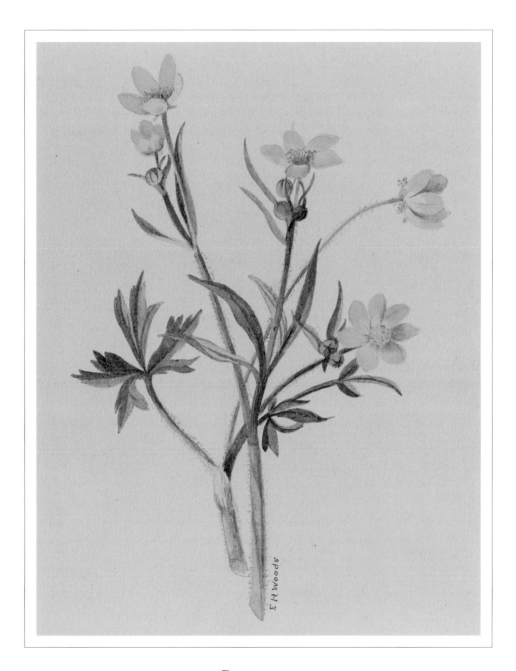

Buttercup
Ranunculus sp.

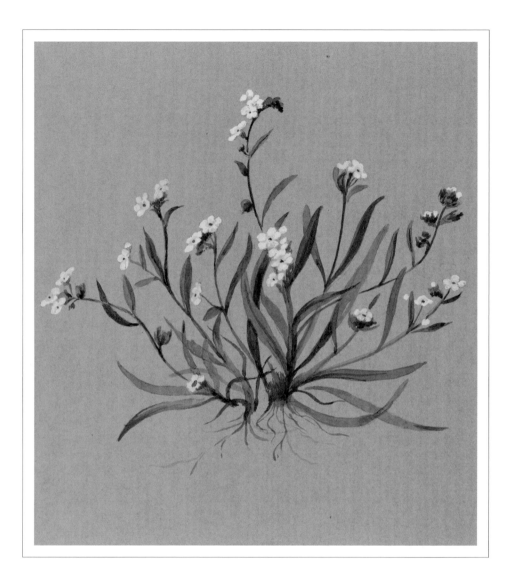

Forget-me-not
Myosotis sp.

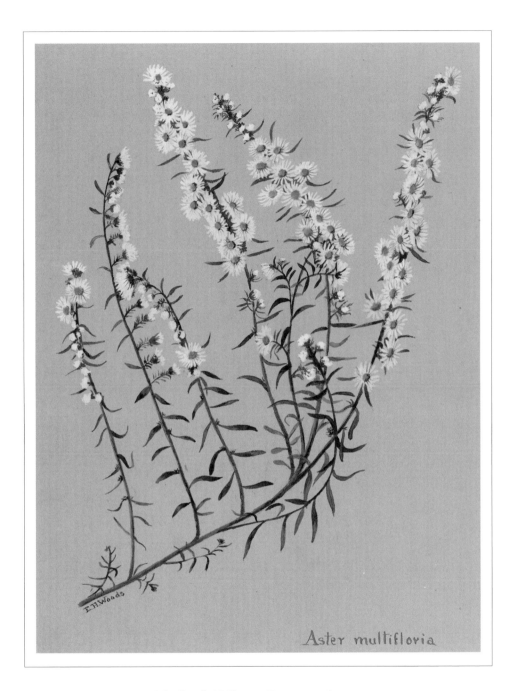

Aster multifloria

Tufted White Prairie Aster
Aster ericoides

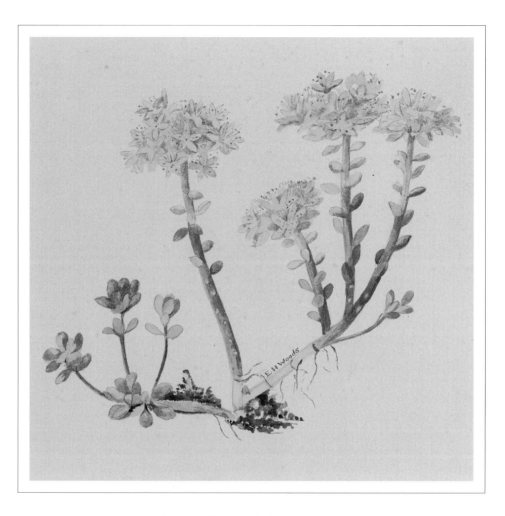

Broad-leaved Stonecrop
Sedum spathulifolium

Stonecrop

The yellowest of all the yellow flowers is stonecrop. She has not the burning yellow of Broom, nor the butter yellow of buttercups. She is not the clear canary yellow of Skunk-cabbage or the toasted yellow of Wild-sunflower. She is just straight yellow, a yellow that cannot be matched.

How any plant can grow on bare rock and be so fleshy leafed and fat is a marvel.

Rocks covered with stone crop, shepherd's purse, blue for-get-me-not and little white sticky-stem are exquisite patchwork no earthly substance or human hand could produce. These four and many others, are "carpet-flowers". Our play house on the big rock in the back field was spread with them.

"Camas" carpeted too but she grew too high to be exactly a carpet-flower, she was more a spread of glory.

Individually Camas was an "honest-to-goodness" flower, a hearty grower not very refined. Each coarse tough stem burst into a head of lush split bells of a hot purplish-blue. She darted from the soil accompanied by a few slivers of ugly green. But Oh! massed Camas was wonderful! Walk away for a few paces and turn sharply. Goodness had the sky tumbled! On her strong stems Camas was rolling in the wind. The blue mass was alive. Light played over her and varied her tones, it was like joy running! Your impulse was to run and run and run till you caught up.

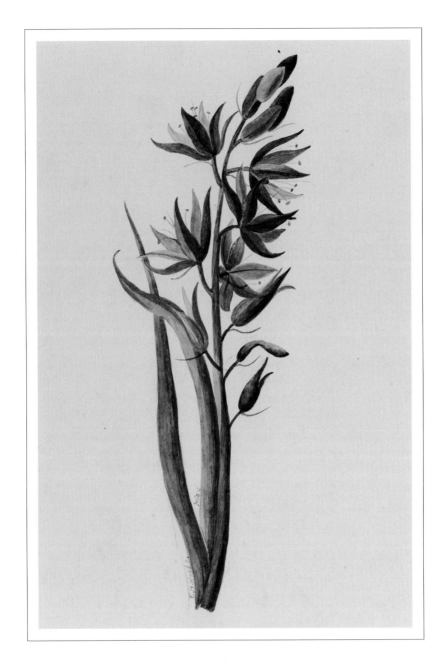

Common Camas
Camassia quamash

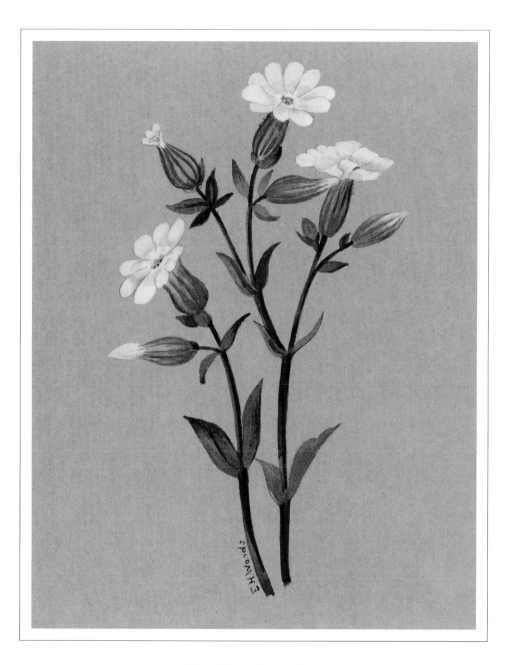

Bladder Campion
Silene vulgaris

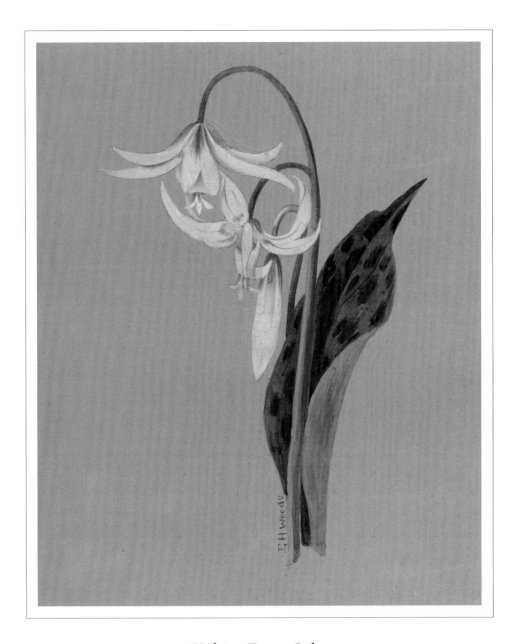

White Fawn Lily
Erythronium oregonum

Wild Lilly

Wild lilly does better than completely delighting to avoid satiety she leaves a tiny margin for longing, for a hungry desire to taste a yet greater perfection, one beyond any experienced, the want that keeps things growing. Each lilly is in herself perfection. To look upon a field-of-wild-lillies is to go further, to leave one quite wordless. Glow of white petals, sheen of green leaves, fragrance. All the goodness of the earth squeezed into one essence.

Lilly droops her face and stares into the soil from a mild brown eye. Her slim pointed petals roll back, back from her face and tremblingly point up like millions of little fingers. In sunny places her stem is sturdy and reddish in shade it is pale. The leaf is cleancut, pointed and mottled with brown. Each lilly has a pair of leaves attached to her stem. If you pull a lilly instead of breaking the stem the flower with leaves attached slips from the earth and next year's bloom is destroyed. Law demands that you break the stem (if gather you must) and do not pull the leaves. Lilly roots lie very deep, from seed which does not mature or bloom for several years.

Wild Lilly leaves town as soon as man takes possession. The plough exterminates her from cultivated fields. Every year you must go farther from the city to seek her. You find her in tangled thickets and untilled soil in cuttings beside roadbeds. She blooms at Eastertime.

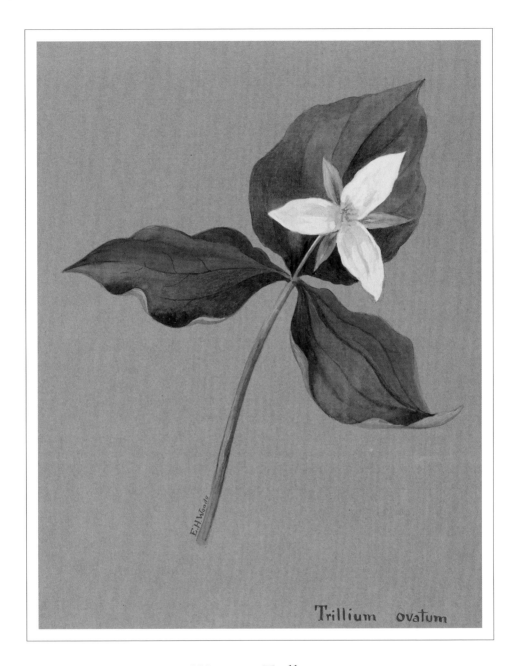

Western Trillium
Trillium ovatum

Trillium

Where ground dips and trees droop. Where dusk creeps early because of the overhang, here grows trillium. In the rich bog soil. She has a clear flesh coloured stem clean-moulded and sturdy, from which unfolds three large plain edged leaves of bright green, they spring from the stem at the same level and broaden out till the three meet: completely circling the stem which goes on growing through the middle of this complete umbrella for about one inch more, then comes the bloom. Three white petals with a golden eye. The petals are so richly, creamily white they might be three big spots of clotted cream lying on a green plate. Trillium is opulent, each flower a queen in her own right, a bouquet and holder all in one. There is stillness round her. The white flowers glow like untwinkling stars each separate, in a sea of green. Each flower holds her tranquil perfection for a considerable time. When death comes to her she blushes a purplish pink and drops her petals. In her heart has formed a berry. By and bye it will turn red as a drop of blood.

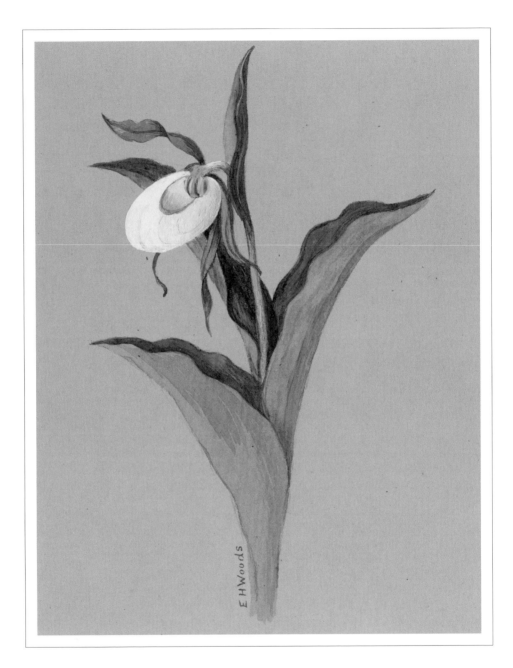

Mountain Lady's-slipper
Cypripedium montanum

Ladies Slipper

Ladies-slipper is an orchid. A jaunty daintiness that dances out of leaf mould in woodsy places where shade is tempered by filtered sunshine and where there is just enough breeze trembling to motivate the delicious pigmy kicks that Ladies-slipper delights to pay wind back with.

Piquant, joyful, lavish in the dispensing of an intense spicey fragrance, a fragrance that strongly resembles that of lilly-of-the-valley but with more of moss and earthiness in it; more hugging than lifting. A murmur of "Earth dear earth!" rather than the sigh, "Ah Heaven!"

Broom

Gilding, Jazzing, Blatantly gorgeous! Broom surges over the land commandeering every vacant spot. Close in her wake follows the tourist: Bleating, blaaing over broom's gilded glory. While tourists intoxicated by Broom's yellowness and smell rave, inhabitants turn from the red-hot-yellow-smell and the teasing pollen that makes them sneeze – shut their doors and windows to keep her out. Farmers curse her for devouring the land their sweat has earned.

Broom on the hill, Broom along the highway, fields of broom, mountains of broom, the forest only is free of her but she waits in the cuttings beside road-beds to pounce as soon as the settler makes a clearing. He may dig, he may cut, he may burn, Broom thrives on thwarting. She is very fruitful. In summer you hear the crackle, crackle of her seed pods bursting – seeds scattering far and near.

In the dry season Broom is a serious fire hazard. The tiniest spark sets her off. She does not pause till she has licked the district clean by the fury of her burning.

Any one who is liable to hay fever gets it during the broom season. How hysterical the tourist does get over Broom's golden glory! We don't feel we have to champion Broom she is an upstart and a squatter. She is <u>not</u> one of our native wild flowers. An early settler brought his pockets full of her and scattered the seed broadcast. Broom needed no coaxing up she sprang and jazzed our land. Women tried making broom wine, the half-plucked bushes looked like moulting fowl. Nobody liked broom wine. The fad died. But Broom went on invading and the tourist went on maudling.

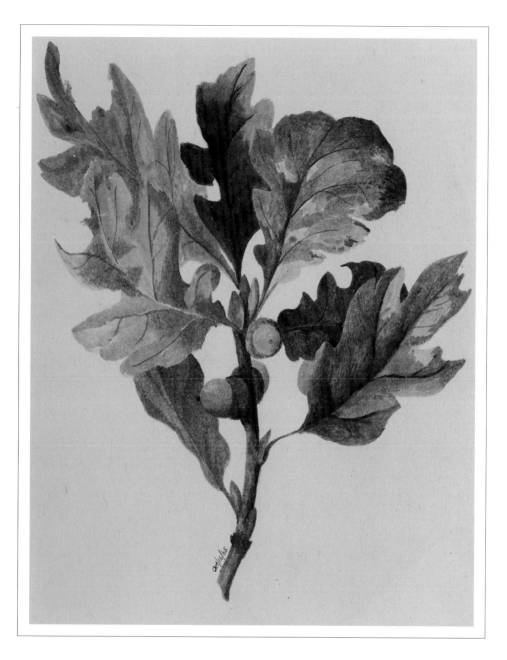

Garry Oak

Quercus garryana

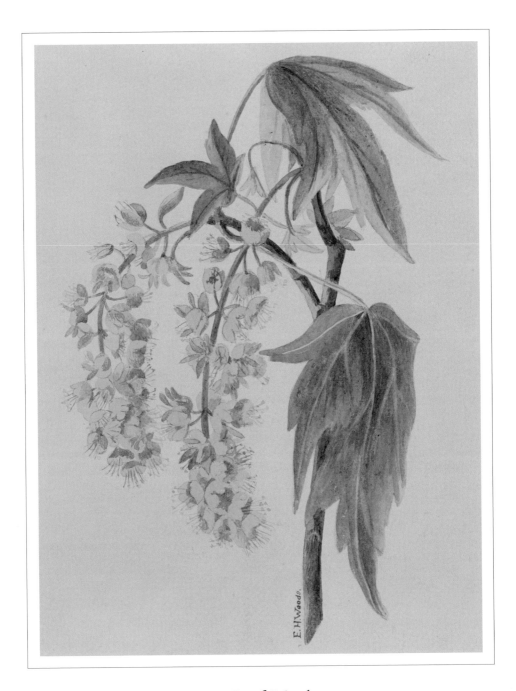

Big Leaf Maple
Acer macrophyllum

Maple

The splendid tree which is Canada's National Emblem is a wholesome tree remarkably free of blights. The variety in the East differs from that of the West. Eastern Maple is hard-wood, small-leafed, Autumn reddened, and in Spring drips syrup. Western Maple is soft-wood has huge leaves is wide spreading in growth, yellows in autumn and produces no syrup in Spring, but her leafing is proceeded by terrific blossoming, dangling tassels of pale greeny-yellow. Each tassel has dozens of little bells about the size of lilly of the valley bells. Each bell swings on its own little neck but all are attached to the main stem of the tassel. The racket of Bees wings furnish the Maples tongueless bells with music butterflies go to her the moment they are released from their chrysalises. She has sweetness for them if she has no syrup for us. The weight of Maples' blossom in Spring and the weight of her foliage in Summer must be tremendous. In Autumn after a sudden pop of brilliant yellow in the woods among the sober pines, she flings her leaves in crisp brown heaps upon the ground and takes a long winter rest.
Quite naked.

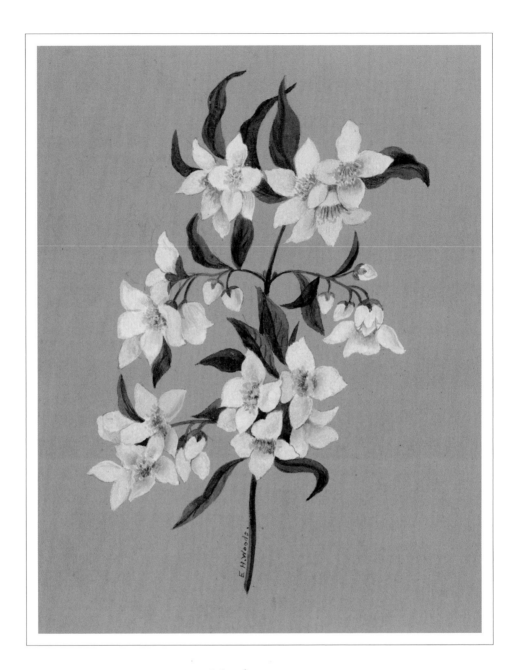

Mock-orange
Philadelphus lewisii

Mock Orange

Mock orange is a perfectly real flower she is only called mock because of being understudy to true orange blossom. She mixes in every ones mind with brides and weddings and she flowers in June, the wedding month. She blesses every bride, that of rich man, poor man, beggerman and thief. The last three get her from the woods for nothing, the first buys her from the florist. She grows quite as comfortably in a nursery garden as in the woods. Her flowers grow profusely on boughs within easy reach of the hand. Her perfume is a close second to the perfume of the blossom of southern orange groves one hardly notices the difference in appearance of real or mock when she nestles among a bride's fixings. She looks – "I belong." She is fresher too than imported <u>real</u> orange blossom.

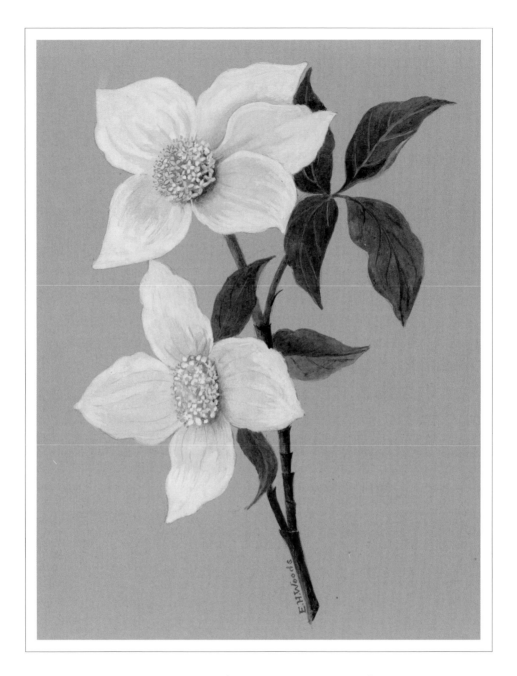

Western Flowering Dogwood
Cornus nuttallii

Dogwood

A child looked up into the middle of a cheery tree in full bloom. "Is it really pop corn?" she asked. Seeing a dog-wood tree in bloom one might ask, "Are they really flap jacks?" So flat and round the blossoms lie among the foliage staring straight up at the sky, badly cooked flapjacks, a brown burn in the centre of each and all around it white.

How tourists do go on about dogwood as they drive over our highways. They force unwilling husbands to stop the car, climb a snake fence, teeter on the top rail in tight city shoes with arms thrashing and hands grabbing, reaching for the flowers. How he tears the limbs from the tree and drapes the wrenched bows over the car to make an impressive entry into the city! I tell you flapjacks would make a more wholesome showing than poor mutilated Dogwood. After the journey. Greyed by dust, pulped by wind, leaf and flower come to town shrunk and draggled. Cobwebs on the end of a broom look as unlovely.

No nursing revives Dogwood she is done. Clank slams the garbage can lid. That is the end of her. "Is that a slap-jack hanging over the side of the can?" No, it is the reproachful brown eye of a dogwood flower draped around with tattered grey that once was creamy white petal.

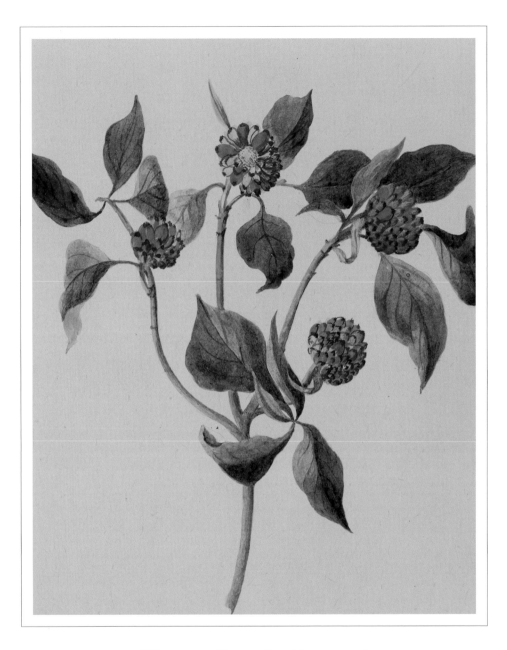

Western Flowering Dogwood
Cornus nuttallii

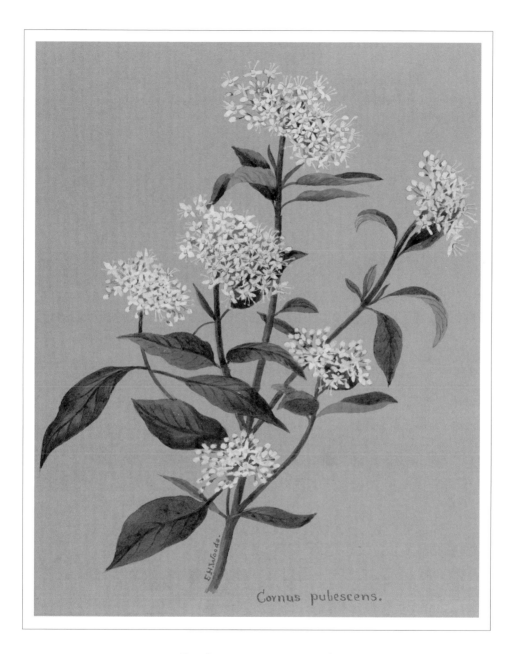

Cornus pubescens.

Red-osier Dogwood
Cornus stolonifera

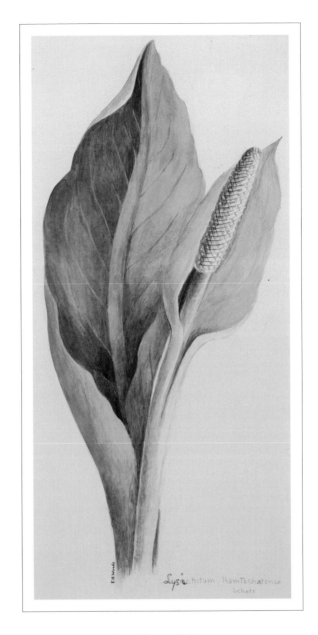

Skunk Cabbage
Lysichiton americanus

Skunk Cabbage

Botanical-science has un-skunked the skunk cabbage. Our bog skunk cabbage now adorns wealthy estates in the old country. All right, but has the un-skunking robbed her of that regal aloofness that was hers in our swamps? That queenship which she held by very reason of her skunkiness, kept people back and left her throned in wild state upon hummocks in the bog amid a setting of lush magnificence flanked by enormous leaves of the brightest glossiest green, backgrounded by the quiet grey of alder boles and the purple dimness of the woods where the unflickering canary yellow of skunk-cabbage globes shone steady in a neutral setting.

In leaf and blossom Skunk-cabbage resembles the arum lily only her leaf is rounder and her trumpet does not flare, the top is closed but there is a slit down one side of the flower through which you see emptiness and a greeny-brown coarse core. The bog about her stinks; a rank smell as if this clearfreshed radiant flower were sucking all impurities, brown ooze, stagnant scum, seepage from putrefying foliage, rotting wood, slime of slug, poison of mosquito: were pulling these foul things into herself collecting them, filtering them through her own purity holding the bog's evils in her own emptiness to clean it, flinging it's vile effluence to the winds.

Skunk cabbage bogs are as eerie as church yards, frogs croak there, humans hurry past.

This is a skunk cabbage story. It happened on Vancouver Island. It is the story of a skunk cabbage, a missionary, and a panther.

Once a lady Missionary lived in a wild place, she
owned a dog. The woods were full of panther. One day the
Missionary and her dog were going to the little store one
mile away to buy food. The forest was dense and there was
no trail she had to walk along the beach. At one point a great
bluff jutted out into the sea. To round the bluff Indians had
cut a little trail through the woods. As she walked the
Missionary sang a hymn and in her hand she carried the
bloom of a skunk cabbage. She was good, perhaps she carried
the flower to discipline her nose. I do not know. As they
approached the bluff the dog gave a yelp and plunged into
the sea. It startled the woman because the dog hated water,
then she saw in the entrance of the path a few feet from her
a great panther his yellow eyes fixed upon her. The
Missionary's hymn turned into a screech with all her might
she flung the skunk cabbage right between the eyes of the
beast which humped its back, spat like a domestic cat, and
slunk into the forest. The water carried the woman's scream.
Settlers came and shot the panther. I have the dried skin
of the beast's paw with five cruel claws attached. I have a
photograph of the Missionary. There are two things I want
to know but the Missionary is dead. Did the skunk-cabbage
or the missionary turn the panther? Why was the
Missionary carrying a skunk-cabbage? Who is there to
answer these riddles?

Salmonberry
Rubus spectabilis

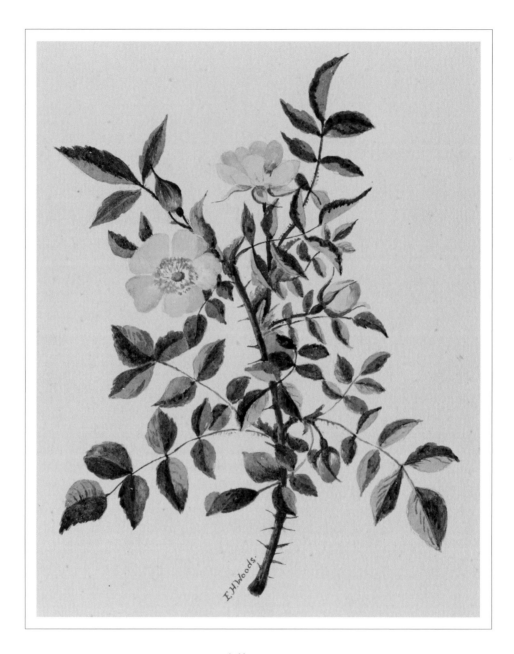

Baldhip Rose
Rosa gymnocarpa

Roses

There are three degrees of rose in Western Canada. The biggest and most common has a flower the size of a silver dollar. The next is as big as the coin we used to call two-bits, which is twenty five cents. A dime could cover the flower of the third.

Big rose is very pink indeed, she grows in the high ways and the byways, a matronly bush with dozens of round welcoming faces. Most reashuring to strangers because she grows in so many lands that she is known to everybody and makes them feel at home. She brightens the edges of our sombre forests blossoming along the highways of this vast new land. Wild Rose loves the jags of zigzag snake fences, hugging herself into the peaks away from scythe and reaping machine. She goes right into the towns with settlers taking possession of empty lots, pushing her way between plank sidewalks and picket fences. She is the last wild bush to be ousted and draws blood if her bushes are molested. You would not believe that such a gracious looking rose could have such thorns.

Big rose has a strong scent, a delightful summery-smell that the hot sunshine fries and makes stronger. Yet, along in the autumn her scarlet hips are very handsome too.

Big rose bounces straight from a tiny tight bud to a wide flat disc of pink, just in a twinkling, no half way. She resents being gathered and flings off her petals in a pet leaving you holding nothing but an unripe core which she would have stayed by and made into a good hip if you had not interfered.

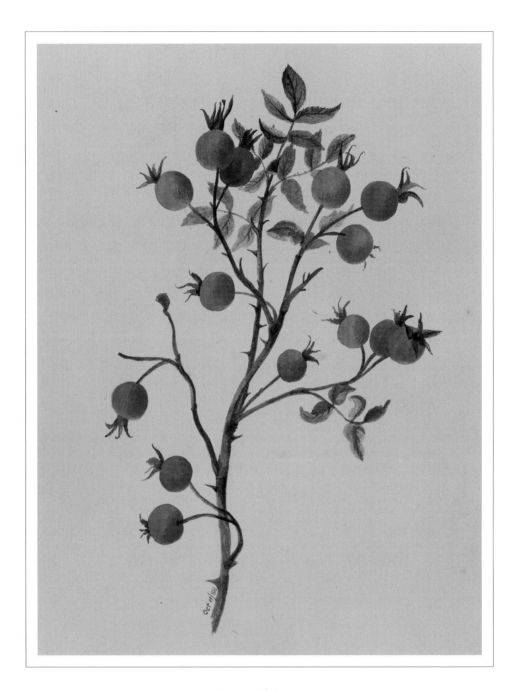

Rose hips
Rosa sp.

Next in size is sweet-briar rose whose leaf is almost as sweet smelling as her blossom. She gives clusters of delicately-tinted ladylike flowers whose petals cup a golden heart. In early morning the cup is full of dew. On the outer rim Sweet Briar's petals are pale pink which fades first to yellow and then to white. The texture of the petals is exceedily refined and semitransparent.

Sweetbriar's heart turns into an elongated scarlet hip: less hard, less red, less round, than the hip of big-rose. She likes to grow in open meadows where her shape can develop symmetrically. You think Sweetbriar is perfect till you come across Fairy-Rose then every other rose seems gross.

Fairy-rose delays her blooming till summer is nearly past. She has nothing to do with the robust hubbub of spring, hers is an ethereal blooming. If a bee lights upon fairy-rose he looks like a great furry bear and bends the branch, thickly set with little needle-fine thorns, to the ground. When bee drones off the branch snaps back to normal – strong, flexible, fine.

Fairy rose is sparing with her blossoms half a dozen blooms on one bow is a crowd. The tiny rosy buds are like drops of blood.

Where overhead clearing has let the sun in, but where the soil is still virgin this is where fairy rose grows. A bush here, a bush there – never very many bushes. Better attempt to chain a gnat than to cultivate Fairy Rose.

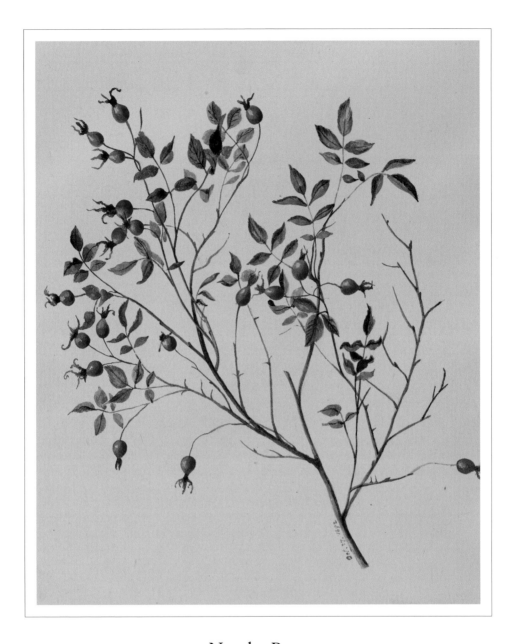

Nootka Rose
Rosa nutkana

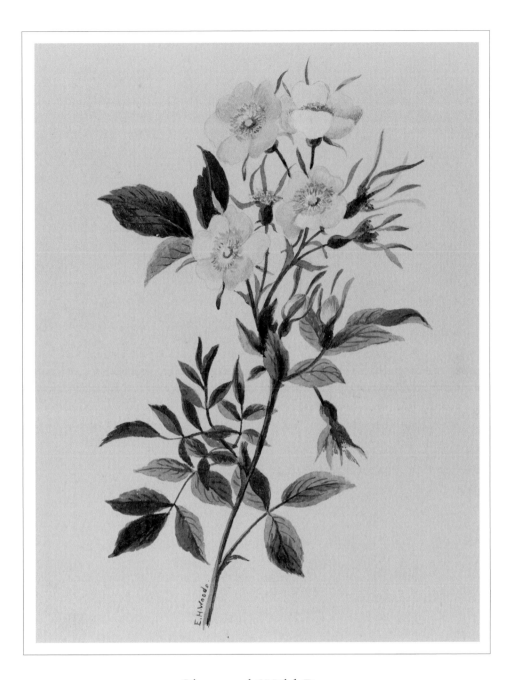

Clustered Wild Rose
Rosa pisocarpa

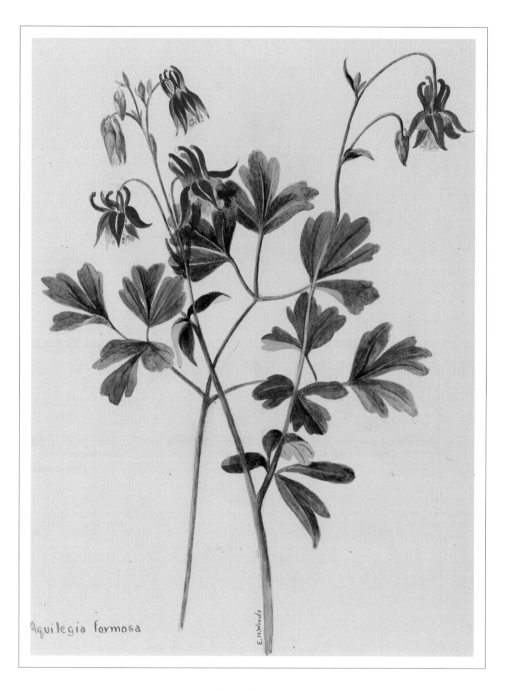

Red Columbine
Aquilegia formosa

Tigerlilly and Columbine

Tigerlilly and Columbine have not anything in common except that they like the same location and the same time of blooming – scorch of full midsummer. Tigerlilly is rounded, full sapped and sturdy. Columbine is spikey, vague, ethereal – seems almost as if she were winged, bobbing and hovering in her thicket you forget that she is rooted, her poise is so delicate her movement so perpetual. Among snarled scrub or swathy bracken you can't miss the steady yellow glare of tiger's eye: for Columbine you must seek. Her petals are tenderly scarlet, her fluted heart yellow, their substance is translucent more like coloured light. Tigers' flesh is solid, opaque, freckled.

Neither Tiger nor Columbine grow in profusion. They do not like the nearness of man: both hang loosely on a sub-branch from the main stem, few roots in a wide area. Tiger and columbine are in the list of semi-rare wild flowers.

Tiger is sweet smelling your own nose tells you so. Columbine is sweet, bee and ant tell you that she has honey. Both flowers have been glorified by science into tame garden varieties. Wild Tiger and Wild Columbine would never tolerate transplanting to the confines of a garden.

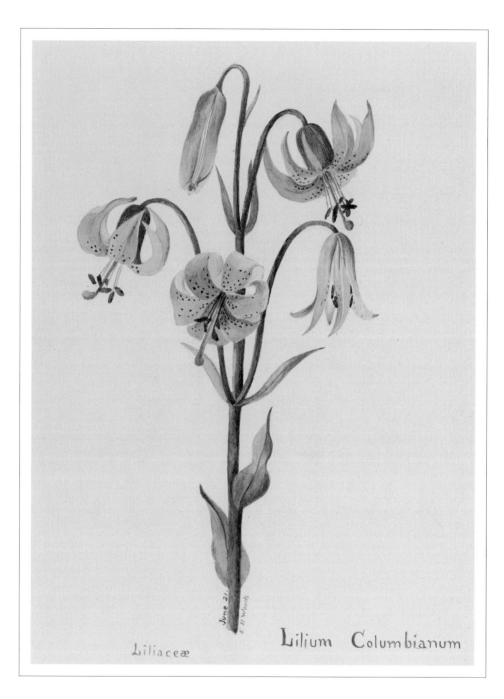

Tiger Lily
Lilium columbianum

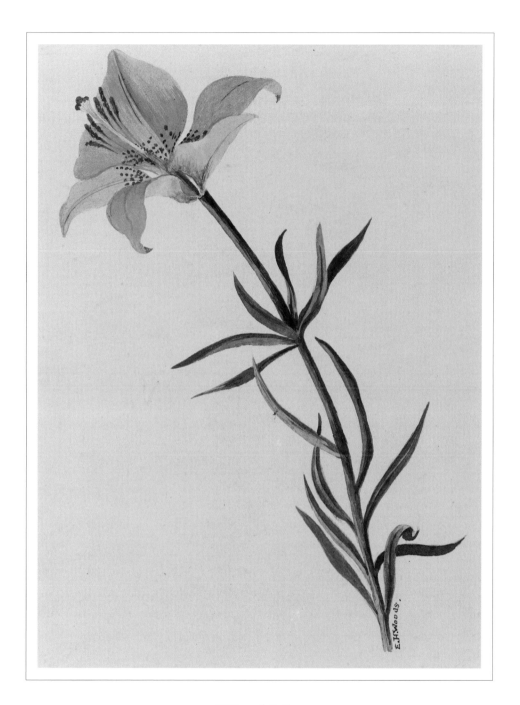

Wood Lily
Lilium philadelphicum

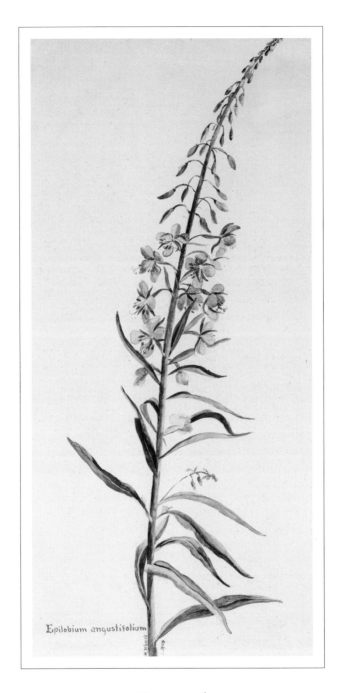

Fireweed
Epilobium angustifolium

Fireweed

Deep under the forest's floor Fireweed has slept for ages and ages. She sleeps but she listens in her sleep. The first crackle of fire and she wakes. While the roar and hiss is above her she is at work making shoots. Before ever the earth is cold she bursts through char and ash hurrying, hurrying, to hide fires hideous scars. The crimson shoots that she bores through the debris are gawky and have dull rank leaves sprouting from them direct, no branching. Each spike produces its own bunch of flowers, a head composed of a quantity of loose-jointed watery little flowers dangling flabbily by their necks from the main stem: insignificant, rickety, ill-nourished looking flowers, cold pink in colour and without smell. The head of the fireweed spike ends in a weakly green point. You would not expect anything so rank of growth to be sensitive, but Fireweed is exceedingly touchy and flops in a wilt at any provocation. Not that any one thinks of gathering her for decorative purposes she is so obviously a weed. Let the sunshine light her petals though and she turns from cold to rosiness lifting the bleak patch of burnt waste into a thing of loveliness. Fireweed is a ministering flower, a hider of scars, a healer. She is the flower of flowers for a new, raw country which must suffer cruel disfigurement in the process of taming.

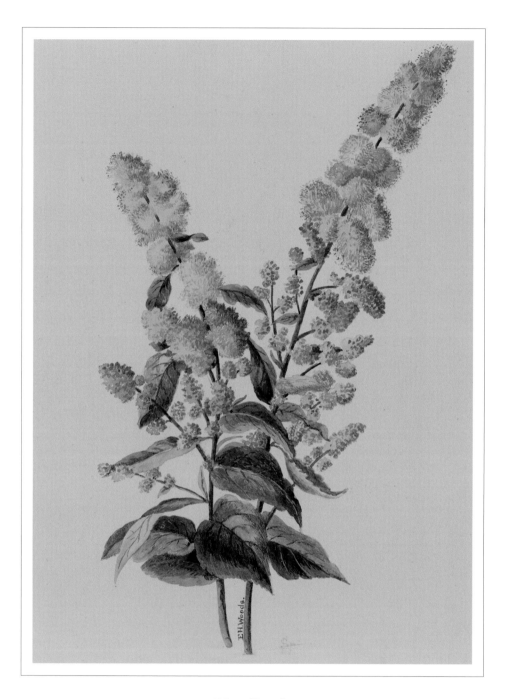

Hardhack
Spirea douglasii

Spirea

Most common of all our flowering shrubs is probably Spirea, an obliging and ornamental bush that will thrive anywhere. High rock, low swamp, along the highway, around the edge of cultivated field, banks overhanging the sea. Rich soil, poor soil, crannies between rocks where there is no soil at all. Spirea grows tall and scraggy, or short and bushy – the limit of her height is about twice that of a man. Her sturdy shoots are supple when they pierce the soil but soon harden into brittle wood, the sap dries to pitch in her stems, her leaves have the dryness of cloth. When Spirea's bunches of flower develop they too are dry and fluffy as carded wool. In bud the big hanging creamy bundles are just bundles of loose-hung granules like farina before it is cooked. They are green and hard swelling slowly to creamy whiteness, each granule bursts and fluffs till the bush looks as if it were gobbed all over with generous helps of farina pudding. No sooner has Spirea fluffed than the sun begins to scorch it and the flowers are burnt and crisped to dark brown, very ugly but still sitting tight, lisping parched little murmurs in the breeze. This papery sound sends the wasps hurrying to Spirea bushes with their building materials to make their round grey nests with the door at the bottom. Nests just as dry and papery in texture as the bush; but the nests are surprisingly strong. They are built around spirea twigs for support and can defy the biggest wind. Everything about the bush and nest is parched and meagre, even the thin angry music of wasps wings.

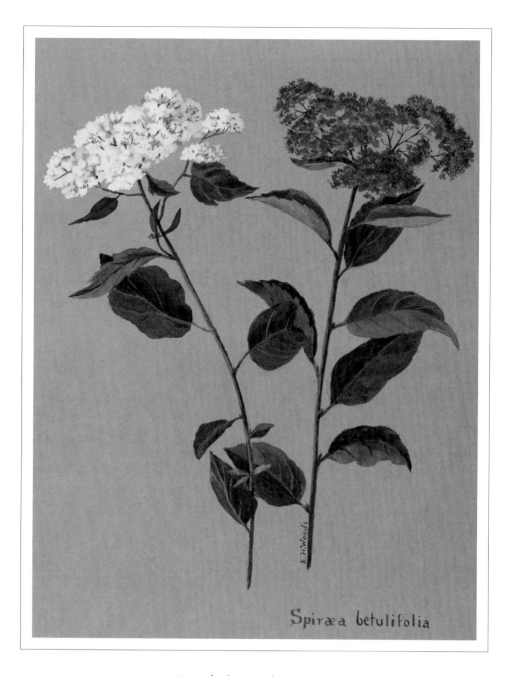

Birch-leaved Spirea
Spirea betulifolia

In early summer Spirea houses the hummingbirds, that is before she has gone brittle and her sap and has not turned to pith nor her leaves to cloth and her bloom is still fluffy white. Humming-bird weaves the most perfect little nest right against the wood of spirea's bough under a fall of blossom. You would think the nest was just a little bulge of lichen until you see the bird sitting in it like a jewel.

Brown Tulip

There is a strange flower brown in colour and brown in smell. As children we called her "Brown Tulip". I cannot tell why because tulips are cup-shaped and look up, our brown tulip was bell-shape and looked down. Her bell was brown spotted vaguely with buff. So sober was her colouring that other flowers appeared brighter for being near her and they made her look drab.

Brown tulip likes unkempt land where there are gnarls of scrub oak no higher than a child, sparsely-leaved scrub that does not keep out the sunshine, tufts of last years withered grasses that whisper in their dryness and protect Brown Tulip's roots.

On Dallas Road was a big oat-field, the upper corner stony and untilled – wild grasses seeded themselves here, growing, withering and growing again. In this corner the bells of Brown Tulip grew the size of nutmegs, ordinarily they were only as big as thimbles. When wind swept from the sea over the oat field Brown Tulip swung her tongueless bells furiously.

On the scruff of every Brown Tulip's neck stood an upright green prong. It was like the iron thing a photographer supported your head with while he took you, it kept your head still, but Brown Tulip would not steady her head on her prong she wanted to droop it so that it could wangle.

"Wild Cyclamen" was a pert flower all spikes and angles – we called her peacock but she was a bright magenta-pink colour with black points. She was sharp in shape, smell,

and colour, all pokes like a half open umbrella. The drab of Brown Tulip Off-set Peacock. But quiet Brown Tulip looked far more distinguished.

Once I found Brown Tulip pictured in a flower catalogue called a "frittilery" and described as something rare, maybe – but she was just our dear old brown tulip.

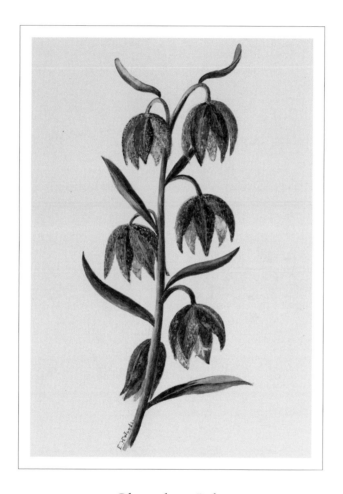

Chocolate Lily
Fritillaria affinis

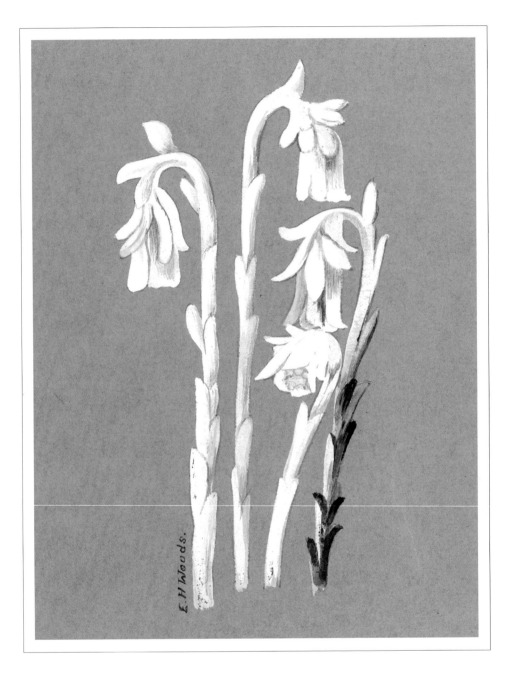

Indian-pipe
Monotropa uniflora

Ghost Flower

Some call her "Indian Pipe", some "Ghost Flower". She is more Ghost than Pipe; growing in eerie woods, a parasite springing from decay, fallen leaves, spent pine needles, mouldering wood, blossoming while these things hover in a state betwixt foliage and leaf mould, a life that belongs neither here nor there, but is quite understood by Ghostflower herself. Vigorously she pushes aside the loose decay, erupting a little mould through which she drives several sturdy hooked necks appearing scruff first. The necks look like corpulent maggots whose heads and tails are still below ground. When Ghost has hooked herself about an inch above the soil she straightens one end of the hook. There is a nobble on the top and this she pokes into the air and it swells and swells then it unfolds into a flower something like the old fashioned columbine before they glorified her spurs and petals. The ghost flower is fleshy in texture and dead white, stalk, leaf and flower. Her leaves climb the stalk clinging like scales. She stands rigid like gobs of milk that have frozen on the purplish floor of the forest; little groups of weird flowers that are rootless, leafless, colourless. Often she comes up under a confusion of fallen twigs which make for her a protective cage, for if wind or sun or human hand touch her she immediately turns black. She is a breath-catching experience. There is within her the quality of illumined tranquility which you see in the afterglow that sometimes lights the face of a corpse.

Catnip

Catnip is not much of a flower except for cats. Catnip was mixed up in my mind with three important things – God's kindness, Doctor Reid's sermons and cats.

I did think it was kind of God to make a special flower for cats.

We were always so glad to reach the catnip bed on our way home from church on Sunday morning because church was far and Dr Reid's sermons and prayers long. Father led us straight from pew to dining table without one stop except at the catnip bed and we gathered a few sprays for our cats. When we got to the catnip bed it was time to begin worrying. The nearer we got to the dinner table the harder we tried to remember something of Dr Reid's sermon for when Father had folded his dinner-napkin, he would say to each of us in turn, "What do you remember of the sermon?" I thought he should not have expected much from me, because he had taken my hat and lent me his sleeve for a pillow. His waking-poke and Dr Reid's "amen" came together.

I could have told Father much better what the cats said to their catnip, how they rolled and rubbed fondling their cheeks against the hairy white down on the back of the catnip leaves, sniffing and smoothing back their whiskers against the flowers that we did not think smelled too nice; purring, purring like bee-hives.

Ladies Slippers
A Story

On and on meandering westward ran the long road. On one side of it a high snake fence built of split cedar poles, on the other side no boundary save the sombre dark of the forest whose density none left the road to penetrate: nor did travellers over the road feel drawn to mount so high and splintery a fence to explore what lay behind the snakey zigzag of the road's other side. The road heaved up and down for the ground was hilly. It squirmed in and out among hills, sank through bogs, dived into stretches of virgin forest. The narrow clearing on either side of the road-bed was blotched with old stumps each a monument to the particular forest tree it had rooted, shorn now of branches, robbed of life-distributing vertebrae; a bled stump bleaching in disintegration. Life was still rampant in the tremendous roots. Earth was stubborn against parting from them – tenacious as an ageing human hugging his ulcerated aching teeth. Reforestation and arboriculture would never substitute these grand original giants satisfactorily any more than a modern dentist can replate happily with artificial dentures. Trees might grow, teeth bite, but what about the smile?

The road was made of dirt spread upon a bed of rock and gravel. Hills drained themselves into swamps.

Where the road passed over swampy land the road-bed looked like a welt raised by a whip that had cut across a face with tears lying on its cheeks. Riverlets and puddles trickled

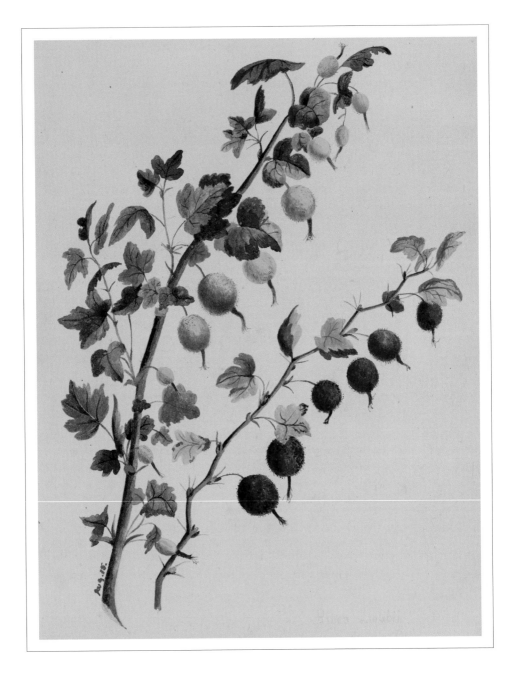

Wild Black Goseberry
Ribes divaricatum

and lay between the leaves of the rank skunk cabbages. Still water invited the sky down to visit but when its clouds and blueness rested on the water cheeky frogs thinking they had got to Heaven croaked such loud hallelujahs! and hopped so violently that the mud under the shallow water got riled and chased the sky back where it belonged.

However much it twisted, however much it rose and sank, it never let you forget that it was a Canadian road, more especially a road in British Columbia – Canada's Pacific edge, just as far West as she could possibly go.

In summer the road was dusty, in winter muddy. Whichever state it was in people hurried over it as fast as its condition would permit staring straight ahead wishful to get the going over and to be at their destination. If they did think at all of what lay on either side of the road it was only to speculate on the worth of land hereabouts, enduring rather than enjoying the unspoiled newness they were passing through, their noses untuned to the luscious scent of the wild lillies, mock orange, wild currant, and deers foot, a large green leaf that smelled like new mown hay. They were quick enough to grumble at the smell of the skunk cabbages in the swamps, but perhaps that was because the mosquitoes teased their noses.

The sweetest perfume of all the woods was that of a little flower called the Ladies Slipper. Its fragrance is beyond describing; spicy as a cordial which warms and penetrates to every vein of the body the perfume of the Ladies Slipper enters the nostrils and circulates delight to the spirit. A subtle perfume compounded of the scent of live grasses,

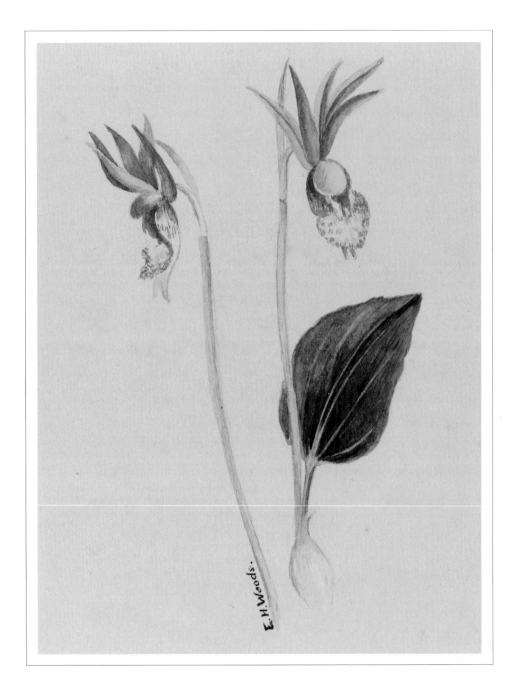

Fairy-slipper
Calypso bulbosa

mosses, earth, heat, dark, silence, wind and sunshine: so perfectly combined as to be completely satisfying.

Behind the snake fence millions and millions of fairy-like little Ladies Slippers hung on half transparent stems as if awaiting the order "Quick March!" you felt that at any moment the surface of every hill and valley might come quiveringly alive with their passing, tardy shy ones peeping from the chinks and crannies beneath fallen logs and brush-piles emerge to scuttle and catch up with the mass which grew more openly in mossy spaces where dapplings of sun-light played upon them through the branches of high trees and where you longed to lie down among the pinkness of the little slippers; to plunge your face among them, to be drunk of their perfume, but instead you stood looking, afraid to move lest you crush them. Their perfume flavoured even your held breath.

The shoe-part of this little flower in actuality is not pink, it is of a translucent flesh colour dappled with brown. The appearance of pink was given by the five upstanding petals behind the heel of each shoe, blades of a vital cool pink more brilliant by reason of their dim woodsey setting. The five upstanding blades trembled very slightly and the little shoes swayed. Had spirit feet just stepped from them? Were they even now invisibly inside the shoes? Was that wonderful fragrance which filled the air their present state? Earth hugged the perfume close seeming to invite you, "kneel and be enveloped too, in my hug."

Your fingers traced a half transparent stem down to its rootage in the loose leaf mould. They found a little globe-like bulb. A fairy electric-light globe, clear with the clearness of a white currant. Each flower was escorted from the bulb by a stout green leaf plain-edged, lowly, always keeping under the level of its flower. The veins ran parallel from stem to tip of the leaf here they bunched into a final twist of fibre.

Nothing could be more earthy than the haunt of the Ladies Slipper, yet to its environment clung a spirituality beyond human understanding almost as if you had stumbled upon one of God's shoe factories, a place where he shod Spirits-in-the-making with slippers from which to take their first step into the beyond where spirits have no more use for shoes, and stepping from them left the little slippers to right themselves to their emptiness. Who knows if after they too have passed through death may not join the Spirit flow, leaving the little luminous bulb rooted in the earth for the making of more Ladies Slippers for more Spirit feet.

Stick to your road of dirt oh human-shoe-of-leather, for you the smell of petrol-haste, horse manure and human sweat. If you feel a call beyond the snake fence go peep between the bars – look, smell, rejoice, but do not plunder. A pair or two of Ladies Slippers withering in a bowl what are they? Climb the fence, bury your face among these God-made slippers, drink of their perfume, but leave them there lest perchance some Spirit-in-the-making might go unshod.

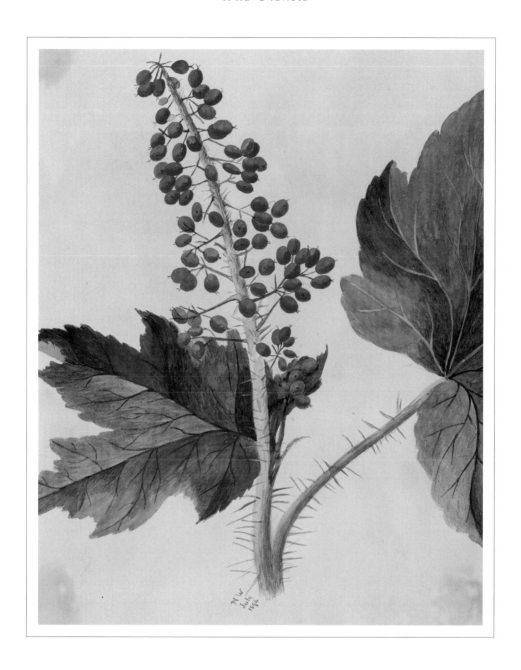

Devil's Club
Oplopanax horridus

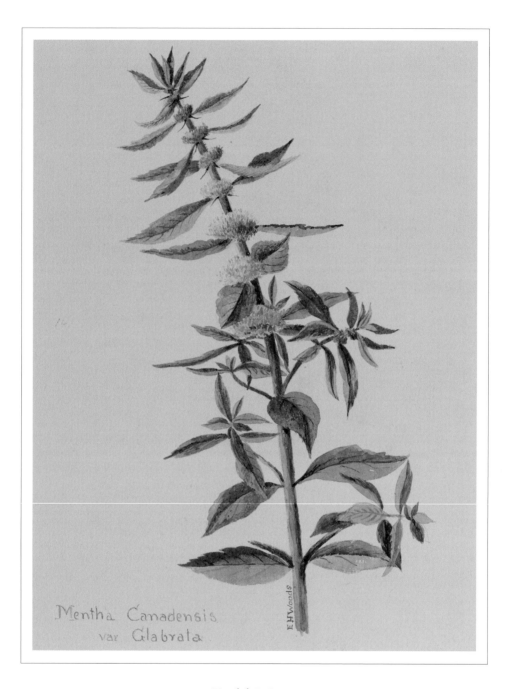

Mentha Canadensis
var Glabrata

E.H.Woods

Field Mint
Mentha arvensis

Mint
A Story

Mint grew all around Marifield cottage, beds of tall, very green mint. The front door of the cottage was never used. It was crawled all over with small white-rose brambles that smelled sweet if the mint was still, but if she was rubbed or crushed or rustled she threw out such a fierce smell that it drowned every other smell.

Mrs Fraser rented Marifield cottage she lived there and had a small private one-room school. It was the first school I ever went to. The school-room was big, it had four windows and a fireplace. Marifield cottage had three other little rooms and the lean-to kitchen as well where Lennie cooked potatoes. Lennie was Mrs Fraser's brother.

I saw Mrs Fraser before she ever had a school, she then lived on a farm a long way from town and kept her husband there. Mr Fraser was "queer" (I did not know about craziness then.) One day Mrs Fraser drove into town and came to see mother and brought her husband. He was a big man with a black beard and stupid eyes. Between every sip of tea he put his cup and saucer on the floor between his feet. Mrs Fraser told Mother that their drive into town had been uncomfortable because Mr Fraser got tired of "going", so he got out and took the wheels off the rig and Mrs Fraser and the horse had to wait till he felt like going again and put the wheels on.

Well, Mr Fraser died and Mrs Fraser cried because she

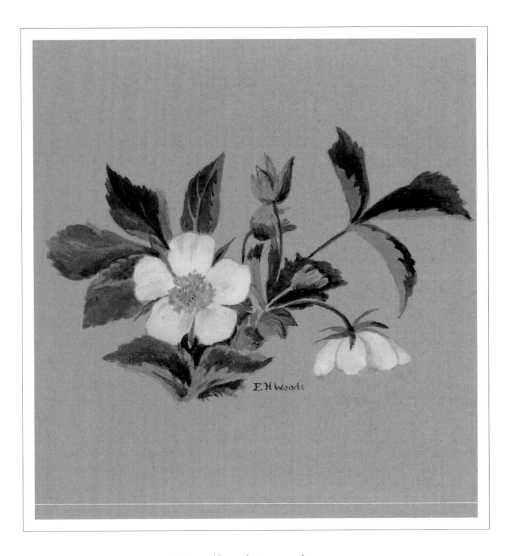

Woodland Strawberry
Fragaria vesca

loved him, even foolish. She came to town and rented Marifield Cottage and the mint. She got six little dogs and her brother Lennie for company and cook in the leanto kitchen. She started her school when I was just big enough to go. The cottage and the mint were quite near our house we used to get mint there to boil with our new potatoes and peas.

As the front door wouldn't open because of the roses we walked on a plank through the mint beds round to the kitchen door. Lennie was always frying potatoes, it was the only thing we ever saw or smelt him cook. When his back was turned we snitched a slice of potato out of the frypan as we came in from recess and had to bolt it red-hot-before getting to the school-room door. Our tongues and stomachs got burnt.

Mrs Fraser's was the nicest school I ever went to. The desks were carpenter-made, wooden and heavy; the ink wells sat in a hole on the top. If you were not careful taking your books in and out of the shelf underneath you bumped the ink well and the ink slopped. Then you lost marks.

At the end of the school-room was a square place made by putting three benches together and leaving one open side. Mrs Fraser's chair was at one end of the open and the dunce-stool at the other. I was generally sitting on the stool; it was very comfortable.

I liked Mrs Fraser. She was kind, had beautiful white teeth, said her words nicely and kept her finger nails clean; people said she was very well bred and well educated.

At recess and lunch-time we went out and sat among the mint. There was a tiny square of rough coarse grass in

one corner. Mrs Fraser used to invite the Bishop's cow "Colie" in to chew it off and save Lennie using a scythe. We liked sitting in the mint best and the cow preferred grass.

Lizzie Mason had a big book of Grimm's fairy-tales illustrated. In our house Father did not approve of Fairy-tales. I loved them and used to beg Lizzie to bring her "Grimm" and read to us in the mint.

May was a pretty girl, with a very fat pigtail of yellow hair. I liked her. There were some other girls and three sisters, called Fanny, Nellie and Edie, who I played with a lot at school and in their own garden. We all had typhoid fever together. There was a girl called Edith one day she made me mad and I dipped an applecore in ink and threw it at her. It made her in an aweful mess. Her mother went to my Mother about it. Mrs Fraser punished me about the applecore, Mother punished me at home about it too and all the school put me into coventry, all except Fanny, Nellie and Edie – it was horrid, made me wish I did not have to go to school to be educated.

I fretted so that Mrs Fraser came in to see Mother about me. She brought three of the little dogs with her. Mother gave her tea in the drawingroom and she said. "Please my dears do not give my little dogs cake it is bad for their figures and there is a dog show coming," but the three little dogs sneaked out of the drawingroom and stole a huge plate of bread and butter cut for our nursery tea.

My clothes smelt of mint for two years, then Mrs Fraser found another husband and took another farm. Lennie and the six little dogs went with her and I went to the public School with Bigger and Middle. It was not half so nice as Mrs Fraser's and the mint and the fairytales.

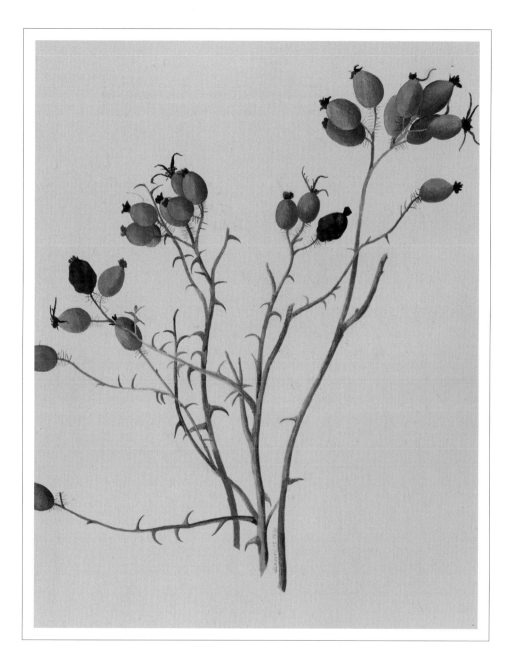

Rose hips
Rosa sp.

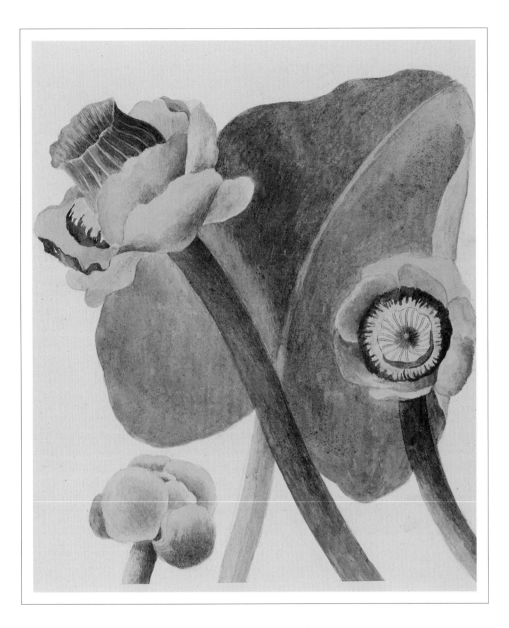

Yellow Pond-lily
Nuphar lutea

The Almost Forgotten Manuscript

Afterword by Kathryn Bridge

"Wild Flowers" has almost been forgotten, overlooked by all but a few researchers who have taken the time to examine Emily Carr's literary manuscripts preserved at the British Columbia Archives. Carr completed this short collection of vignettes in February 1941, while recuperating from a stroke. The forced inactivity was irksome to such a creative person. Although painting might be too strenuous, writing – including her correspondence and a journal – was not. She may have been unable to tackle the physicality of wielding large canvasses and easels, but her ever-percolating imagination transferred itself into word-pictures.

Carr's sense of self was very clearly linked to her environment. For many decades she sketched outdoors, camped and lived close to nature. Adjusting to forced inactivity and a slower pace did not come easily, although, as she described in a letter to her friend, Flora Hamilton Burns in February 1941: "my head is out in the garden even if my heels are not so active."[1] Completing *Wild Flowers* that month coincided with the upswing in weather. "I begin to tickle to get out into the woods, too early just yet..." she said in a letter to Humphrey Toms.[2] It was that magical time of year when the Victoria winter doldrums – the rain, wind and grey, grey skies – are broken by a few sunny days with real warmth in the air. Carr eagerly awaited the advent of new flowers poking their heads up out of soil, the promise of blossoms and bees.

She sent a copy of the manuscript to Flora Hamilton Burns, who was one of her "listening ladies", a patient and loyal friend who had taken a night-school journalism course with Carr in 1926. "Here is Wild Flowers let me know <u>how</u> she <u>hits you</u> & don't keep <u>too</u> long (I take that 2nd part back you are a busy woman & what's the hurry? There <u>are not</u> 25 publishers standing on my doorstep with wallets open) I only spoke from my hateful impatience. Here's "hey ho!" no news. Love of all kinds, Millie."[3]

But soon her optimism plummeted. Ranting in her private journal, Carr recorded:

> I finished "Wild Flowers" and gave it to my sentimental

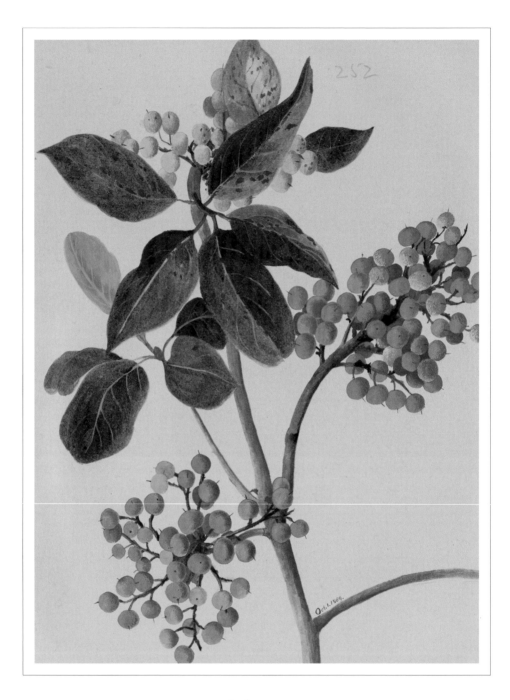

Arbutus
Arbutus menziesii

critic [Flora Burns]. She rang me with volumes of assurance that the manuscript had arrived safely – silence – 'Did you read it?' – long hesitation – 'Yes' – then ha's and hem's. Of course I knew it had not registered. She began picking on the construction. It had no plot. (Of course it had no plot but it had something else; it had life.) Flower character it had but that had passed right over her. I have not the least doubt it is rough, unlettered, unpolished, but I <u>know</u> my flowers live. I <u>know</u> there is keen knowledge and observation in it. I don't know how much one should be influenced by crits. I <u>do know</u> my mechanics are poor. I realize that when I read good literature, but I know lots of excellently written stuff says nothing. Is it better to say <u>nothing</u> politely or to say <u>something</u> poorly? I suppose only if one says something ultra-honest, ultra-true, some deep realizing of life, can it make the grade, ride over the top, having surmounted mechanics.

I was so disheartened by my critic I felt like giving up. For a week I have lain flat but today I perked slightly and decid[ed] what my other two critics have to say will interest me. If all 3 agree as to "Wild Flowers" badness I'll either quit or hide; I won't show anything to anybody again but I think I shall work on still & I still feel there is something in "Wild Flowers." I've never read anything quite like it describing flowers character & habits & haunts. There is no <u>burning</u> element & I don't want there to be it is like pictorial matter in a painting, a lady and a beach with a parasol, a cow, a kitten. People demand something to pin their thoughts to. The rusley silent growing the breath of life is not enough. They must yell & whoop for their pure being is not enough.[4]

True to her plan, Carr sent the manuscript to others. Before she received the disappointing telephone call from Flora Burns, Emily had already mentioned "Wild Flowers" to Ira Dilworth, whom she had met in 1939.

Dilworth (former Victoria High School English teacher and then regional director for the Canadian Broadcasting Corporation) lived in Vancouver and had been introduced to Carr's writings when Ruth Humphrey (another of Carr's listening ladies) lent him a grouping of Carr's stories about her experiences in visiting First Nations villages. Dilworth was extremely impressed with Carr's creative writing and had agreed to edit these

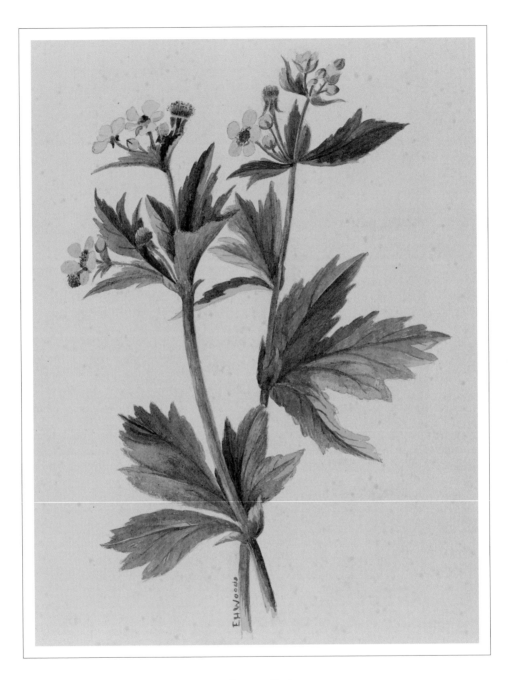

Large-leaved Avens
Geum macrophyllum

stories for publication. He became her champion, eliciting interest through on-air readings in 1940 of some of these stories and through his own personal overtures to publishing houses. Carr got along well with Dilworth, noting to fellow artist Nan Cheney, "he is always very kind and helpful in his criticisms & I believe quite honest as well, & knows & points faults out not just quibble for the sake of quibbling as so many do I find, people who <u>want</u> to be critics!"[5]

In 1941, Carr and Dilworth were still at a formal stage of acquaintance as their letters to each other attest, he wrote "Dear Miss Carr" and she replied "Dear Mr Dilworth." Over time their literary relationship became a friendship and nicknames developed. Dilworth signed himself "Eye" to Carr's "Small." But for now, in February 1941, Carr wrote to him and mentioned the *Wild Flowers* manuscript. Dilworth replied:

> Of course I want to see it. Anything you do will always interest me and I shall always try to let you know frankly what I think. The wild flower bit should interest me very specially. I was always devoted to the out-of-doors and particularly to wild flowers both in the Okanagan and Victoria. Indeed one of the things I miss and have always missed in Vancouver is that marvellous wealth of flowers which Victoria possesses.[6]

Ten days later she wrote:

> Dear Mr Dilworth... here's the M.S. – another disappointment – I always <u>think</u> they are going to be better than they are and when they are not, I'm sore. Words on paper show up all slovenless & ignorance so very plainly. Isn't there a difference in thinking & doing? I still think writing is good because it shows you all sorts of shortcomings you did not know you had. I don't see how any one who writes could ever feel <u>conceited</u> unless perhaps he knew <u>every rule of the game</u> & knew how to think clear thoughts and how to <u>express</u> them perhaps then he might have good reason.
>
> Well anyhow if 'Wild Flowers' is a poor thing it helped me tremendously over a bad time & I am grateful to the flowers. Don't keep me <u>too</u> long waiting for your reaction to "Wild Flowers" I was not born with patience nor have I acquired it.[7]

Dilworth, writing from his CBC office in Vancouver, responded promptly:

> Dear Miss Carr, thank you very much for your letter

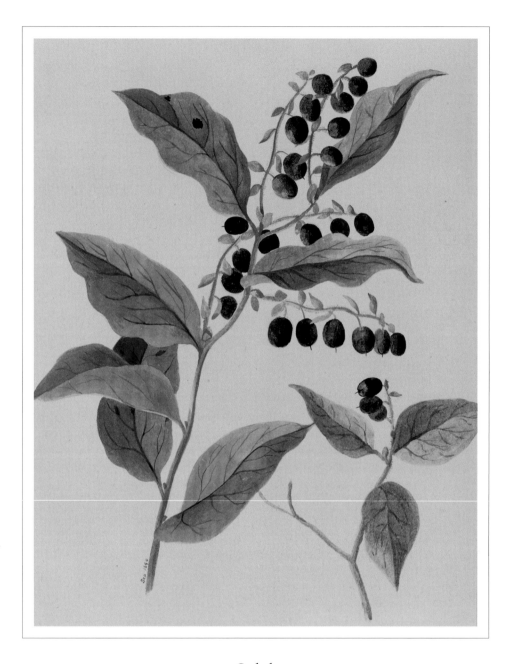

Salal
Gaultheria shallon

> written last Friday and the enclosed manuscript "Wild
> Flowers".... I have found really delightful. I should like to
> set down some notes about it. First of all generally, as I
> have said, it is delightful. Your writing makes the flowers
> very real. As you have suggested, there are a number of
> places where the script will have to be altered – spellings
> corrected, punctuation put in, but these are not important.
> They can be adjusted. The thing that is so interesting is
> that we have such a fresh and delightful account of some
> of our B.C. plants and flowers. Not all the sketches are
> equally successful in my opinion. I should, therefore, like
> to make a few notes if I may....[8]

And then Dilworth goes on to speak of specific vignettes. The letter
is left mid stream, and Dilworth adds a handwritten note.

> At this point my dictation was interrupted and I did not
> get back to it for a whole week. I am concluding the letter
> as I fly East. I am "up in the air" literally as I write – we
> have just left Winnipeg. As a matter of fact I am not "up
> in the air" figuratively any more than usual. When you
> are up here you just can't do anything about anything – so
> it is just as well to give in & take things as they come.
> The rest of the wild flower sketches I shall deal with
> some fine day. "Catnip" is one of the best....[9]

On this trip Dilworth also stopped in at the editorial Toronto offices
of Oxford University Press to give a nudge to manager, W.H. (Bill) Clarke
whom he had sent Carr's "Indian" stories some months back. The result was
an agreement and commitment on Clarke's behalf to publish. Emily had
known something was in the works, but it was not until now, upon
Dilworth's return, that she dared hope. The deal was formally sealed in
March when Bill Clarke and his wife, Irene, came west to introduce them-
selves and have the first of a series of meetings with Carr. Contract signed,
"Klee Wyck" (as the stories would soon be called) was to be published before
year-end. It was a hectic editorial and printing schedule. Needless to say, in
this fervour of preparation and manuscript revisions, Carr filed her modest
"Wild Flowers" away for later attention. She never got back to it.

Just before Christmas 1941, *Klee Wyck* was published and to instant
popular and critical acclaim. The first edition was sold out by year's end. It
won the Governor General's Award for Literary Excellence, and has been in
continuous print since this time. In quick succession, Oxford then published
The Book of Small (1942), followed by *The House of All Sorts* (1944). In
March 1945, Emily Carr died.

Posthumous publications of Carr's literary works were undertaken under Dilworth's supervision, including *Growing Pains: The Autobiography of Emily Carr* (1946), *Pause: A Sketchbook* (1953) and *Heart of a Peacock* (1953). *Hundreds and Thousands: The Journals of Emily Carr* (1966) was completed by Dilworth's niece and adopted daughter, Phyllis Dilworth Inglis. *An Address by Emily Carr* and *Fresh Seeing*, two slim volumes of Carr's public addresses, appeared in 1955 and 1972 respectively. In 2003, *Opposite Contraries, the Unknown Journals of Emily Carr and Other Writings* added a few more of the unpublished stories and most of the expurgated parts of her journals not published in *Hundreds and Thousands*.

Carr loved gardens and flowers, nature in general. Many of the stories in her books are set within gardens or describe flowers in both cultivated and wild settings. Some flowers such as lilies are featured in several stories. It is interesting to compare the story of "Mint" in *Wild Flowers* with the story "Schools" in *The Book of Small*. The characters, setting and plot are identical. The way the story is told, though, is completely different. In "Mint" the focus is on the gardens that triggered Carr's memories and provided the impetus for writing the story. In "Schools" these garden details are gone and the story revolves around teachers and education.

When Carr died she bequeathed to Ira Dilworth an old steamer trunk filled with her sketchbooks, letters, journals and drafts for stories. Dilworth published many of the stories in the years following, but "Wild Flowers" was not published until now. The entire contents of this steamer trunk, along with many other manuscripts and artistic works by Emily Carr are held by the British Columbia Archives. This rich resource is *the* central source for documentation about Carr and is consulted by researchers and incorporated in exhibitions worldwide as the interest in Emily Carr continues unabated.

1. Emily Carr to Flora Hamilton Burns, Tuesday [February 1941], MS-2786, BC Archives.
2. Emily Carr to Humphrey Toms, 16 February 1941, MS-2545, BC Archives.
3. Emily Carr to Flora Hamilton Burns, Tuesday [February 1941], MS-2786, BC Archives.
4. Emily Carr Journal, 21 February 1941. Abridged version published in *Hundreds and Thousands*, Clarke Irwin, 1971 and in Susan Crean, *Opposite Contraries, the unknown journals of Emily Carr and other writings*, Douglas & McIntyre, 2003. Full version in original journal, MS-2181, BC Archives.
5. Emily Carr to Nan Cheney postmarked 13 February 1941. University of British Columbia Special Collections.
6. Ira Dilworth to Emily Carr, 5 February 1941. MS-2181, BC Archives.
7. Emily Carr to Ira Dilworth, Friday [February 15 1941], MS-2181, BC Archives.
8. Ira Dilworth to Emily Carr, 20 February 1941, MS-2181, BC Archives.
9. Ira Dilworth to Emily Carr, 2 March 1941 addendum to letter of 20 February 1941, MS-2181, BC Archives.

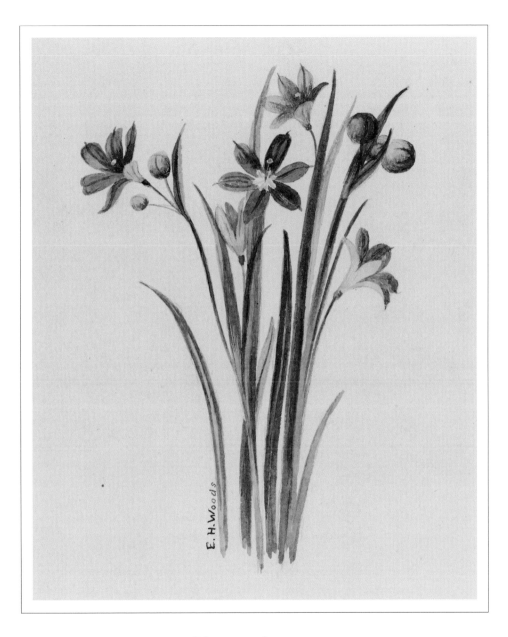

Blue-eyed-grass
Sisyrinchium littorale

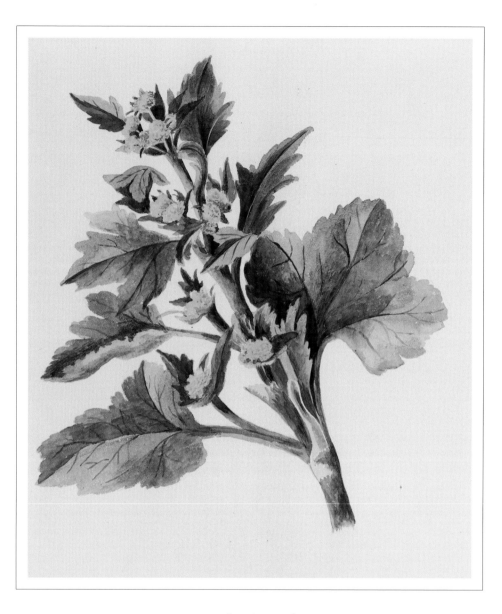

Pacific Sanicle
Sanicula crassicaulis

Notes on the Illustrations

Emily H. Woods painted wildflowers life size, but it was necessary to adjust the sizes of those printed in this book to fit the page. The scale may be different for each painting reproduced here. All of Woods' original watercolours reside in three large bound volumes in the BC Archives, each painting with a catalogue number, shown below. Woods labelled all her paintings, but many names have changed over time. The names below each painting are those in current usage; "sp." denotes an undetermined species.

Front cover: *Cornus canadensis* (Bunchberry or Dwarf Dogwood) resplendent in bunched berries. PDP4138
Back cover: *Cornus canadensis* (Bunchberry or Dwarf Dogwood) in flower shows its similarity to other dogwoods. PDP4138

Page

2 *Balsamorhiza deltoidea* (Deltoid Balsamroot) is rare in British Columbia, found only on southern Vancouver Island. PDP3917

5 *Abronia latifolia* (Yellow Sand-verbena). PDP3900

7 Page from Carr's manuscript. MS-2181

8 *Delphinium* sp. (larkspur). PDP3957

10 *Corylus cornuta* (Hazelnut). Woods labelled it by the alternative name, *Corylus rostrata*, a name now used to describe a variety of Hazelnut, *Corylus cornuta* var. *rostrata*. PDP3953

12 *Ribes sanguineum* (Red Flowering Currant). PDP4032

14 *Ribes divaricatum* (Wild Black Gooseberry). PDP4031

15 *Oemleria cerasiformis* (Indian-plum or Osoberry) is almost certainly Carr's unknown "self-assertive bouncer", a well-known early bloomer that, according to Jim Pojar and Andy MacKinnon (in *Plants of Coastal British Columbia*, 1994), has an "unusual fragrance (something between watermelon rind and cat urine)". PDP4110

16 *Salix scouleriana* (Scouler's Willow). PDP4039

18 *Ranunculus uncinatus* (Little Buttercup). PDP4029

20 *Aster* sp. Asters are related to daisies. PDP3915

21 *Ranunculus* sp. (buttercup). PDP4030

22 *Myosotis* sp. (forget-me-not). PDP4100

23 *Aster ericoides* (Tufted White Prairie Aster) is an interior plant. *Aster mullifloria* may have been an old name for this species. PDP3916

24 *Sedum spathulifolium* (Broad-leaved Stonecrop). PDP4047

26 *Camassia quamash* (Common Camas). PDP3928

27 *Silene vulgaris* (Bladder Campion) is in the same genus as other weedy, introduced species plants commonly called campions and catchflies, most with hairy, sticky stems. PDP4048

28 *Erythronium oregonum* (White Fawn Lily). PDP3967

30 *Trillium ovatum* (Western Trillium). PDP4071

32 *Cypripedium montanum* (Mountain Lady's-slipper or Moccasin Flower). PDP3956

35 *Quercus garryana* (Garry Oak) is restricted in Canada to meadowlands on the southeastern tip of Vancouver Island and some Gulf Islands. Many Garry Oak meadows are threatened by the invasive Scotch Broom (*Cytisus scoparius*), which was introduced to Vancouver Island in 1850. Carr mentions broom being a serious fire hazard. Even more combustible is Gorse (*Ulex europaeus*), another introduced shrub that resembles broom with its yellow flowers (though Gorse has nasty spines, absent in broom). Woods did not paint a broom bush, so Garry Oak seems an appropriate substitute. PDP4114

36 *Acer macrophyllum* (Big Leaf Maple). PDP3901

38 *Philadelphus lewisii* (Mock-orange). PDP4015

40 The blossom of *Cornus nuttallii* (Western Flowering Dogwood or Pacific Dogwood) is the floral emblem of British Columbia. PDP3949

42 Some birds like the berry-like fruits of *Cornus nuttallii* (Western Flowering Dogwood or Pacific Dogwood) that grow in clusters, but humans find them inedible. PDP4149

43 *Cornus stolonifera* (Red-osier Dogwood) is a shrubby species of dogwood. Woods called it *Cornus pubescens*, a name that was used in her time. PDP3950

44 *Lysichiton americanus* (Skunk Cabbage, Yellow Arum or Swamp Lantern). *Lysichitum kamtschatense* is an old name for this species. PDP3996

47 *Rubus spectabilis* (Salmonberry) often grows near *Lysichiton americanus* (Skunk Cabbage) in wet, shaded forests. PDP4037

48 *Rosa gymnocarpa* (Baldhip Rose). PDP4033

50 *Rosa* sp. (rose). PDP4116

52 *Rosa nutkana* (Nootka Rose). PDP4147

53 *Rosa pisocarpa* (Clustered Wild Rose). PDP4035

54 *Aquilegia formosa* (Red Columbine). PDP3911

56 *Lilium columbianum* (Tiger Lily). PDP3988

57 *Lilium philadelphicum* (Wood Lily). PDP3989

58 *Epilobium angustifolium* (Fireweed). PDP3960

60 *Spirea douglasii* (Hardhack) is the species Carr refers to. PDP4059

62 *Spirea betulifolia* (Birch-leaved Spirea) is an inland species. PDP4057

65 *Fritillaria affinis* (Chocolate Lily) is likely the flower Carr called a Brown Tulip, because she mentions a catalogue reference as "frittilery", which resembles the genus name. PDP3970

66 *Monotropa uniflora* (Indian-pipe or Ghost Flower). PDP4007

70 *Ribes divaricatum* (Wild Black Gooseberry), a kind of flowering currant. PDP 4144

72 *Calypso bulbosa* (Fairy-slipper) is an orchid similar to *Cypripedium montanum* (Mountain Lady's-slipper). PDP3927

75 *Oplopanax horridus* (Devil's Club) grows in moist forested areas like the one Carr describes in her story. It's named for the curved, spiny stem that, when you step on the base, can whip up and club you. Both the scientific and common names are unfortunate and ironic when you consider that this relative of ginseng is one of the most important medicinal plants to coastal First Peoples. PDP4145

76 *Mentha arvensis* (Field Mint) is highly variable and found all around the northern latitudes. Woods called it *Mentha canadensis* var. *glabrata*, because in her time the North American plant may have been considered a different species with several varieties. PDP4001

78 *Fragaria vesca* (Woodland Strawberry). PDP3969

81 *Rosa* sp. (rose). PDP4141

82 *Nuphar lutea* (Yellow Pond-lily). PDP4008

84 *Arbutus menziesii* (Arbutus or Pacific Madrone). PDP4153

86 *Geum macrophyllum* (Large-leaved Avens). PDP3976

88 *Gaultheria shallon* (Salal). PDP4136

91 *Sisyrinchium littorale* (Blue-eyed-grass) in an iris, not a grass (as the English common name suggests). PDP4049

92 *Sanicula crassicaulis* (Pacific Sanicle). PDP4044

96 Assorted mushrooms. PDP4150

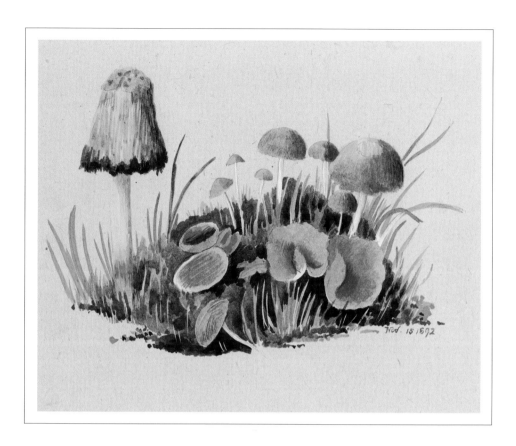

Assorted Mushrooms